To Bob and Jan –
Enjoy the journey!
Cara Ellen Modisett

Blue Ridge Parkway
Simply beautiful

Photography by **Pat** and **Chuck Blackley**
Text by **Cara Ellen Modisett**

FARCOUNTRY
PRESS

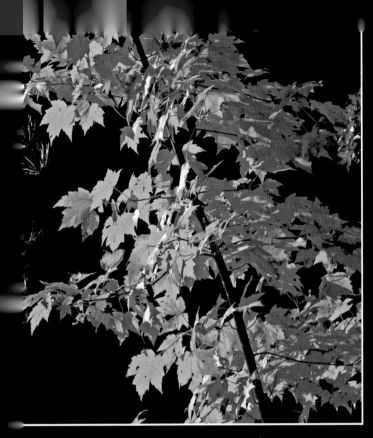

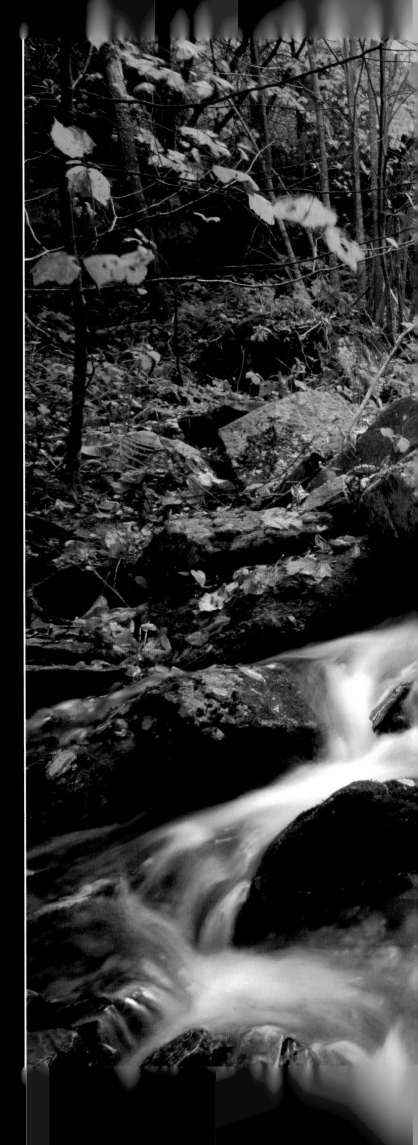

Above: Autumn light glows through maple leaves at Sherando Lake, a George Washington National Forest recreation area.

Right: The stream beside Virginia's Apple Orchard Waterfall Trail tumbles among mossy boulders topped with fallen leaves.

Title page: Sharp Top, one of three mountains making up Virginia's Peaks of Otter, once marked the northern edge of the Cherokee Nation.

Cover: A pastoral view from Ravens Roost.

Back cover: Soft light graces the area at sunset, seen from Thunder Ridge.

SBN 10: 1-56037-447-0
SBN 13: 978-1-56037-447-3

© 2008 by Farcountry Press
Photography © 2008 by Pat and Chuck Blackley

For more information about our books, write Farcountry Press, P.O. Box 5630, Helena, MT 59604; call (800) 821-3874; or visit www.farcountrypress.com.

Created, produced, and designed in the United States.
Printed in China.

12 11 10 09 08 1 2 3 4 5 6

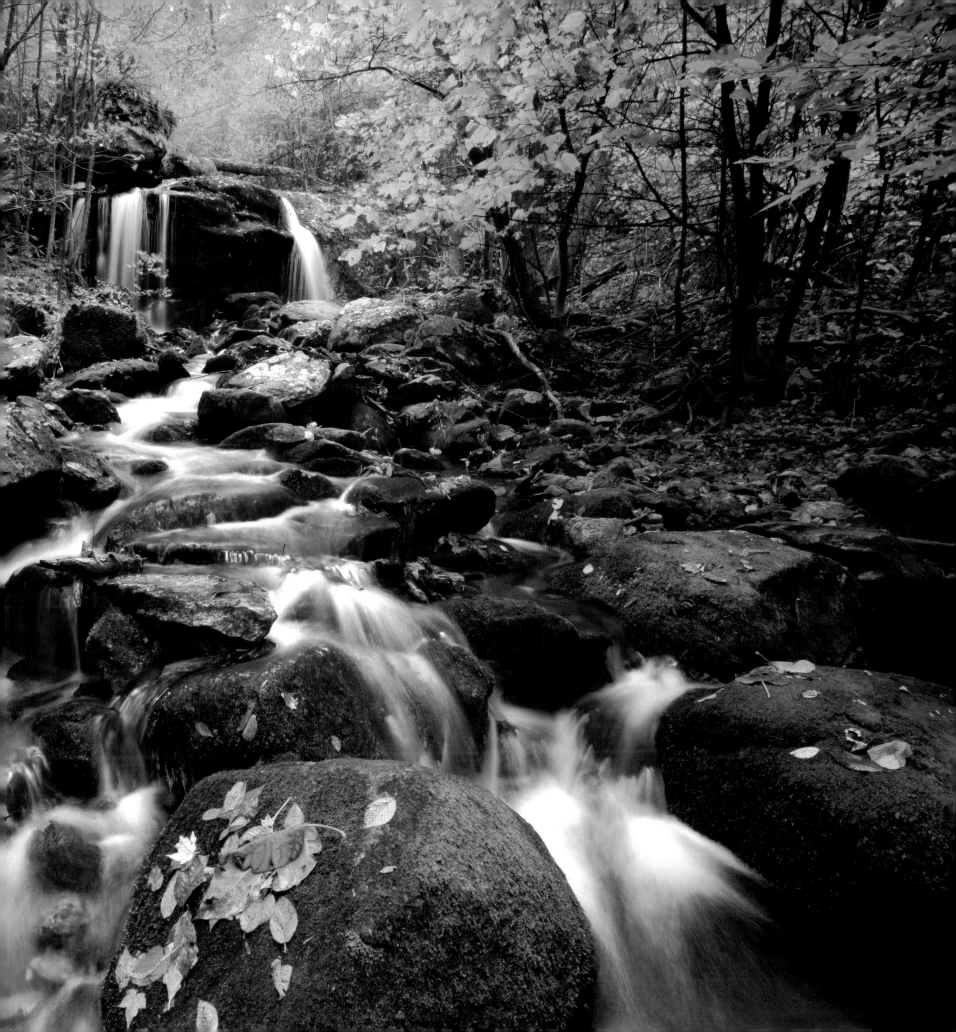

Introduction

By Cara Ellen Modisett

One of my earliest adult memories of the Blue Ridge Parkway was during winter. I was traveling with friends from college, and we drove up into the mountains from Tennessee through North Carolina, heading from Johnson City to Cherokee, climbing up the parkway at its southern terminus and into the high ridges.

What I remember wasn't the far-reaching views, the monumental heights of the peaks, the sweep of the road, or the beautiful construction of the stone tunnels and bridges. What I remember is walking under the branches of trees, every twig encased in ice. I remember driving away, looking back one last time and seeing the ice glisten in the sunlight, the effect of that cold, brilliant sparkle.

To me, that memory defines the beauty of the Blue Ridge Parkway. It's both the great and the small, the momentary and the perpetual, the transitory and the unchanging.

The Blue Ridge Parkway is many things. Officially, it's a unit in the national park system. By the numbers, it's 469 miles long, a roadway that travels between valley and ridgetop, from an elevation of 649 feet (the James River in Virginia) to 6,047 feet (Richland Balsam in North Carolina). Two hundred seventeen miles are in Virginia; 252 are in North Carolina. In the north, the parkway begins at Afton Mountain; in the south, at Cherokee. There are twenty-six tunnels along the parkway, twenty-five of them in North Carolina. There are nine campgrounds, fourteen picnic areas, and more than 100 hiking trails.

The parkway inspires metaphor. Its designer and first landscape architect, Stanley Abbott, described it as "the brush from a comet's tail." Historian Harley Jolley called it a "grand balcony." The parkway is so unusual, so singular, so beautiful, it's difficult not to wax a little poetic when describing it.

The parkway is a feat of engineering and design. The graceful curve of the Linn Cove Viaduct (the very last segment of the parkway to be completed, soaring around the wildlife preserves and scenic beauty of Grandfather Mountain), every one of its twenty-six tunnels, and the road itself, constructed on the slopes and peaks of mountains, were a work of modern innovation. But beyond that, the careful planning of experience and the reminiscent framing of faraway views with trees and rock outcroppings go beyond engineering. They turn a road into a work of art, a continuous series of living paintings that one can step into and out of with every stop along the way.

The parkway is a cross-section of history. It took fifty-two years to build, and it began in the middle—specifically, at Cumberland Knob, nearly at the Virginia/North Carolina line —on September 11, 1935. Its final route was established at the end of a long political debate among states and legislators. The Blue Ridge Parkway might have wound into South Carolina or Tennessee. The decisive bill was passed in 1936, introduced by North Carolina congressman Robert Lee Doughton (for whom Doughton Park is named) and signed by President Franklin D. Roosevelt. The vision of its first landscape architect, Stanley Abbott (the namesake of Abbott Lake at Peaks of Otter, in Virginia), allowed the parkway to come into being, a long roadway strung with gems of destinations, overlooks, preserved history, and geological wonders.

The final segment of the parkway was completed on September 11, 1987. Think of what happened around and beyond the parkway during that time: from the turmoil of World War II, the end of segregation, the Korean and Vietnam wars, from the moon landing and beginning and end of the Cold War to color television, nuclear power, and the personal computer. The country and the world were transformed, but the parkway continued its long and interrupted evolution, a road with a sedate speed limit of 45 mph.

The parkway was a saving grace in the economic crisis of its early days, the Great Depression. But in a way, the Depression prompted the building of the parkway, as otherwise unemployed members of the Civilian Conservation Corps constructed cabins, blazed trails, landscaped terrain, and built roads. The results of their work remain today.

And the parkway whispers of a history even older than that, a prehistory that stretches back far before humanity's memories. We have only been in this region about 8,000 years. The mountains have been here much longer—an estimated 230 million years. Their foundations are even older yet—ancient rock that once lay beneath vast oceans between 500 million and one billion years ago.

The parkway is a bridge. Its 469 miles stretch between two other eastern national parks—Shenandoah National Park/Skyline Drive in Virginia and Great Smoky Mountains National Park in North Carolina and Tennessee. Miles of trails cross and parallel its length, connecting with other important paths, including the Appalachian Trail and the Mountains-to-Sea Trail.

The parkway is a living museum. Restored farmsteads and mills, the remains of communities, and the stones of family cemeteries can be seen along its corridor. These sites stand as reminders of where many of us came from: pioneering families who survived and thrived in these high, sometimes unforgiving mountains. Interpreters and historians at parkway campgrounds and historic sites demonstrate the skills and tell the stories of those people, memories that might otherwise disappear. Musicians play old-time and traditional music at the Blue Ridge Music Center near Galax, at Mabry Mill, and in communities adjacent to the parkway's corridor.

The parkway is a home for diversity. Fifty-four species of mammals live here, as do 400 species of moss and 2,000 species of fungi. Twenty-one species of salamanders live on Grandfather Mountain, including three that were first discovered there. Twenty species of warblers sing on the parkway. Of its 1,250 species of vascular plants, fifty are threatened or endangered.

The parkway is a road of peace. Those were the words of a Cherokee Indian in 1959, speaking during a ritual celebrating a landmark in the parkway's history, remembering that once this land was one of bloodshed and conflict between European settlers and Native Americans. Today, it is a sanctuary from the conflict of the outside world, the politics and pettiness of modern life.

The parkway is irreplaceable. In the last century, the great American chestnut was wiped off the face of the continent. In this century, we may lose the hemlock as well. Animal habitats are shrinking. Air pollution is clouding the views. Development is eating away at the park's borders.

The Blue Ridge Parkway is a valuable and unique place, partly because it ever came to be. It is rare for an environmental, artistic, and conservationist vision such as this to grow and thrive. The area's history and beauty and natural resources would disappear without the protection the parkway provides.

The parkway offers a life lesson through its seeming imperviousness, its actual fragility. The endless views of deep-blue and purple ridges receding across the miles remind us how old and beautiful this earth is (and how young and foolish we are living in it). The small experiences, the personal events we take with us along the road—the glimmer of ice on tree branches—are just as important as the grand experiences, and perhaps teach us more.

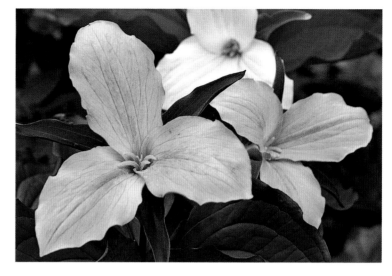

Above: Large-flowered trillium, a member of the lily family, blooms from April through June. The white petals warm to pink over time.

Below: The fresh greens of late spring frame Flat Rock, an outcropping of gray quartzite and white quartz southeast of North Carolina's Grandfather Mountain.

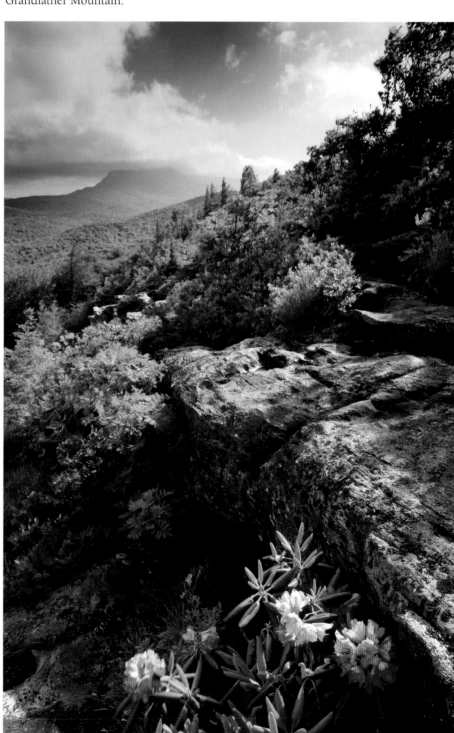

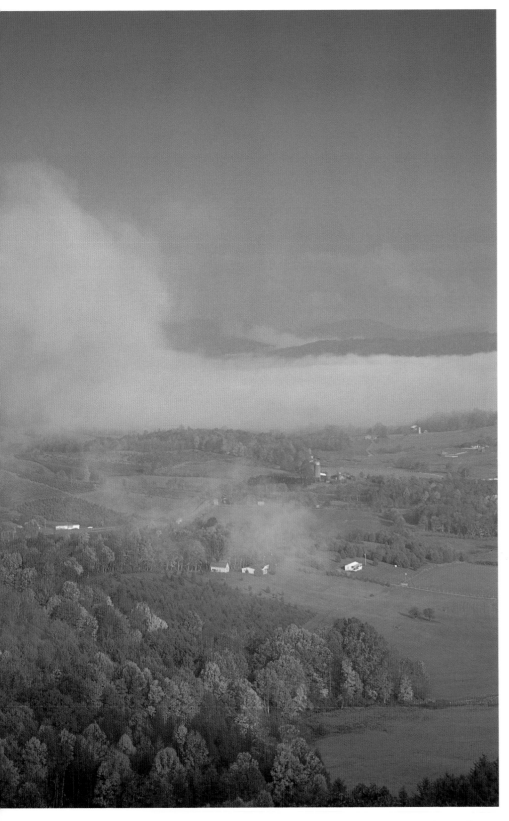

Above: The fog lifts, revealing a pastoral scene near Sparta, North Carolina. Agriculture has long been part of the region the Blue Ridge Parkway traverses, and farmland was incorporated into the parkway's original design. In the years since the road was built, agricultural leases and conservation plans have helped ensure that land adjacent to the parkway remains undeveloped, and that responsible agricultural practices are used on neighboring farmland.

The book you hold in your hands is the second publication of Blue Ridge Parkway images by photographers Pat and Chuck Blackley, produced in part to support and promote the mission of *Friends of the Blue Ridge Parkway, Inc.* (FRIENDS), a nonprofit organization based in Roanoke, Virginia. FRIENDS marks its twentieth anniversary during the year of this book's publication, so this volume celebrates two decades in the life of a vital organization dedicated to the preservation and celebration of the Blue Ridge Parkway.

Why is Friends' work important?

If you've hiked a trail on the Blue Ridge Parkway, you've enjoyed the benefits of FRIENDS at work. If you've stopped at a visitor center with travel questions or picked up a map to help you plan your drive down the parkway, FRIENDS has had an impact on your trip. If your children or grandchildren have learned how to fish at Peaks of Otter, or if you've discovered something new in an interpretive program at Mabry Mill, crossed a bridge at the Blue Ridge Music Center, or admired the split-rail fences along the drive, it's because of FRIENDS.

FRIENDS funds research, recruits and manages volunteers, plants trees, builds trails, maintains campgrounds, and paints mileposts.

The parkway's unusual, linear layout—469 miles long, but in places only hundreds of feet wide—means that land beyond the parkway's limit, called "viewsheds," can be altered without limitation. Development—everything from suburbs to car dealerships—has encroached on the landscape beyond the parkway's official limits, in places damaging or destroying the visual experiences the parkway's planners so carefully created.

In its signature project, FRIENDS has worked with the National Park Service, land trust and community groups, and local governments to restore parkway views. Since 1997, FRIENDS has organized tree plantings at various points on the parkway, bringing people together, young and old, to help restore these

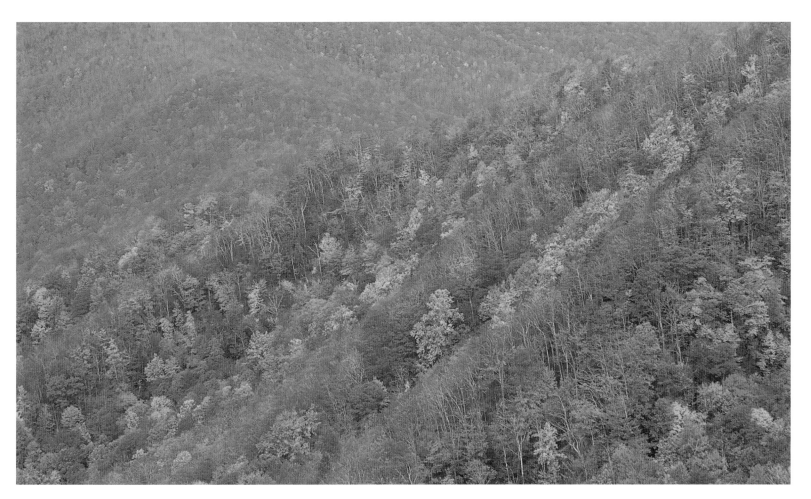

Above: The slow change of seasons is visible in the Green Knob area, around milepost 350 in North Carolina. A lookout tower perches atop Green Knob, elevation 5,070 feet.

endangered sections by returning them to their natural state. In 2004, FRIENDS successfully spearheaded the designation of twenty-eight miles of parkway in Virginia as a Last Chance Landscape. Following that, FRIENDS was recognized by Scenic Virginia, receiving an award for Best Preservation of a Scenic Viewshed. The Association for the Preservation of Antiquities presented FRIENDS with its Founder's Award for the organization's work on viewshed restoration.

FRIENDS isn't just about grand views, however. The organization also pays close attention to small concerns, supporting research on bog turtles—a quiet, endangered species whose habitat is becoming limited—and research on the hemlock woolly adelgid, a tiny insect that's infecting the great trees along the parkway, killing the stately hemlocks just as the chestnuts were lost in the last century.

FRIENDS' work has become more important than ever before, as federal funding has not kept up with the park's needs. Staff positions remain vacant, and the resulting numbers are disturbing: There is one interpreter for every 2.8 million visitors to the park, and one out of three jobs is not being done.

As the Blue Ridge Parkway draws close to its seventy-fifth anniversary in 2010, the involvement of individuals and volunteers becomes more and more vital to its survival. How can you help?

Join Friends. Look for a chapter in your area; if there isn't one, start one. You can find FRIENDS on the web at www.BlueRidgeFriends.org.

Friends of the Blue Ridge Parkway, Inc. is a 501(c)(3) nonprofit corporation, organized and existing under the laws of the State of North Carolina and the Commonwealth of Virginia, whose current principal business address for identification purposes is P.O. Box 20986, Roanoke, Virginia 24014. Tax ID #: 58-1854404. Consider how you can make a difference for future generations through your support of FRIENDS.

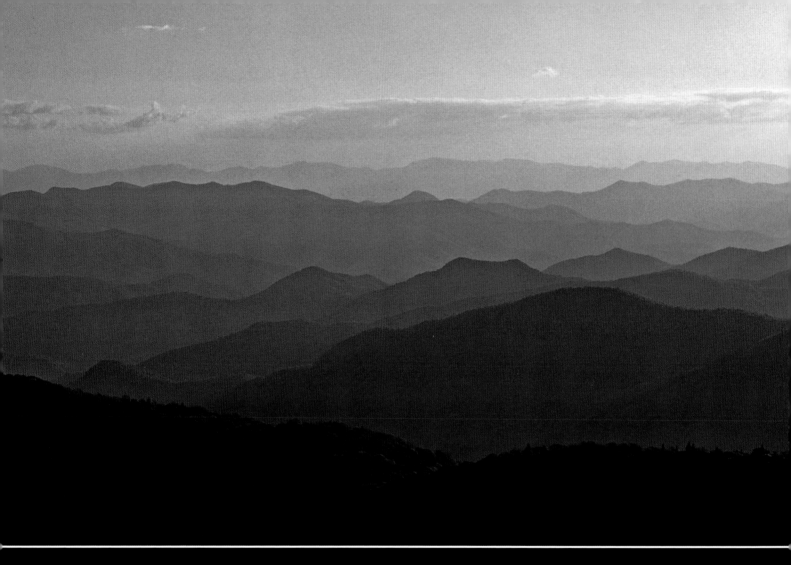

Above: The sun sets at the Cowee Overlook, near the highest point on the Blue Ridge Parkway (Richland Balsam in North Carolina), with a view of the Cowee Mountains.

Right: A lizard, one of the region's smaller residents, clings to a fence.

Facing Page: The rising sun burns through fog at Wildcat Rock in North Carolina's Doughton Park. Named after U.S. Representative Robert Doughton, who played a major role in the establishment of the Blue Ridge Parkway, the park was once the site of Basin Cove, a small but thriving community eventually wiped out by a massive flood in 1916.

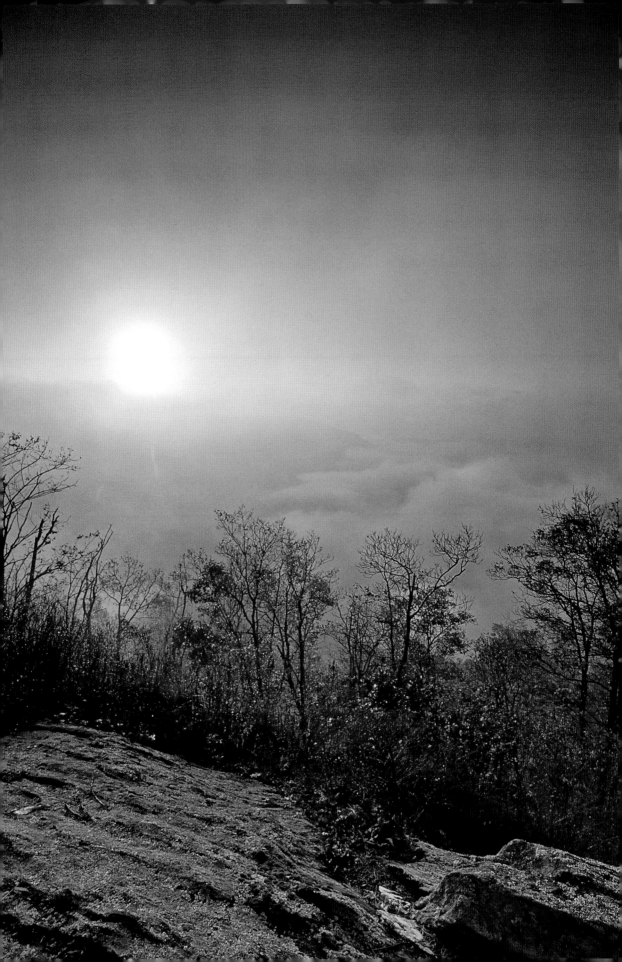

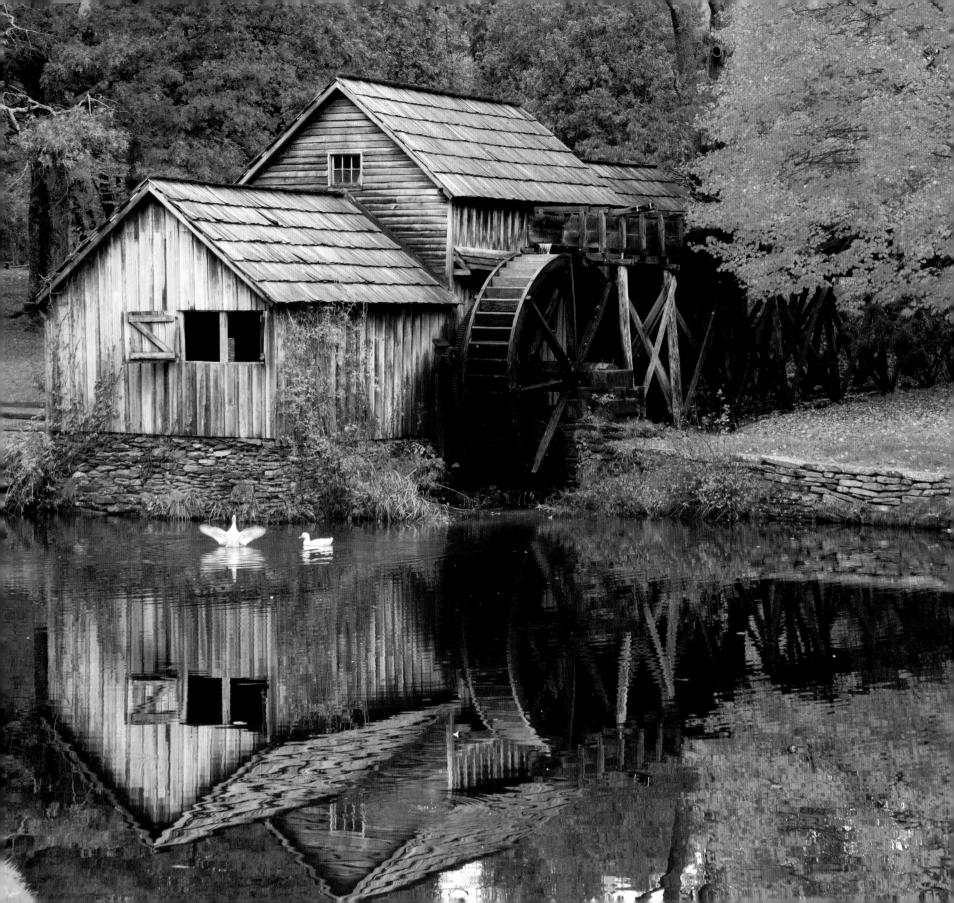

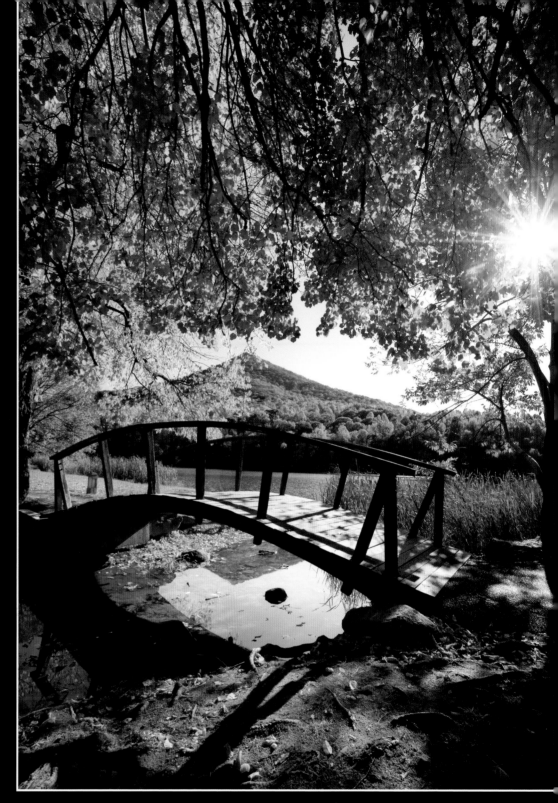

Above: Abbott Lake Loop Trail and the lake beyond, at Peaks of Otter, are named after Stanley Abbott, the parkway's designer and first resident landscape architect. Sharp Top is visible in the background.

Left: First operated by Ed and Lizzie Mabry between 1910 and the mid-1930s, Mabry Mill, in Virginia, has been restored and is now the site of live mountain music, as well as milling and blacksmithing demonstrations.

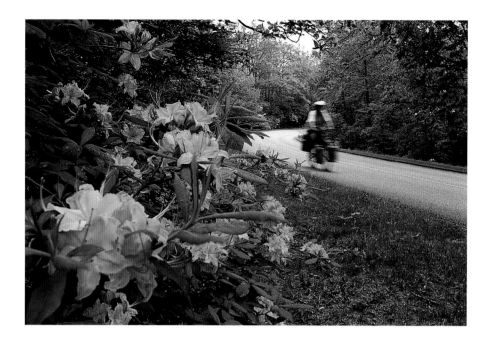

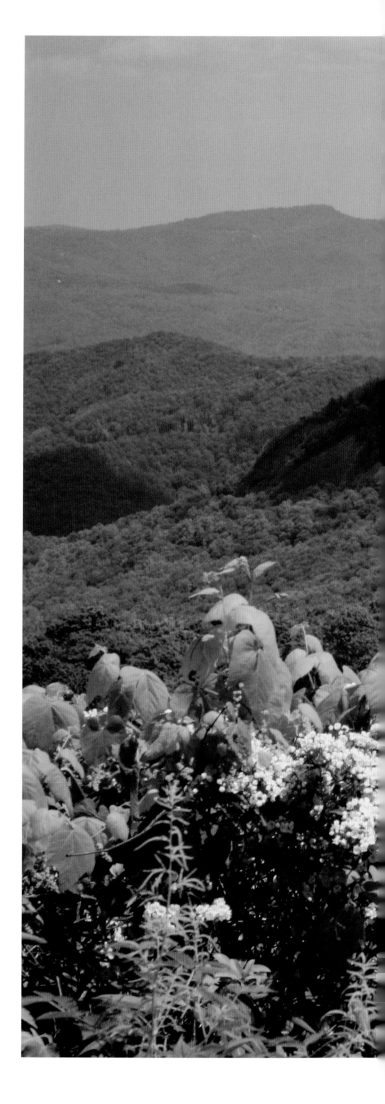

Above, top: Flame azalea blooms in Fancy Gap (Virginia) as a cyclist spins past. The mostly orange flowers (though they can also range into the reds) can be seen in the Appalachians from April through June. Bicyclists can be seen summer and fall, too.

Above, bottom: Little Switzerland, North Carolina, used to be called Grassy Mountain. In 1909, lawyer Heriot Clarkson renamed it for the views and began transforming it into a resort community.

Right: Blue Ridge Parkway designers planned the route with the views in mind, including the dramatic Looking Glass Rock (elevation 3,969 feet), seen from the overlook at milepost 417.5.

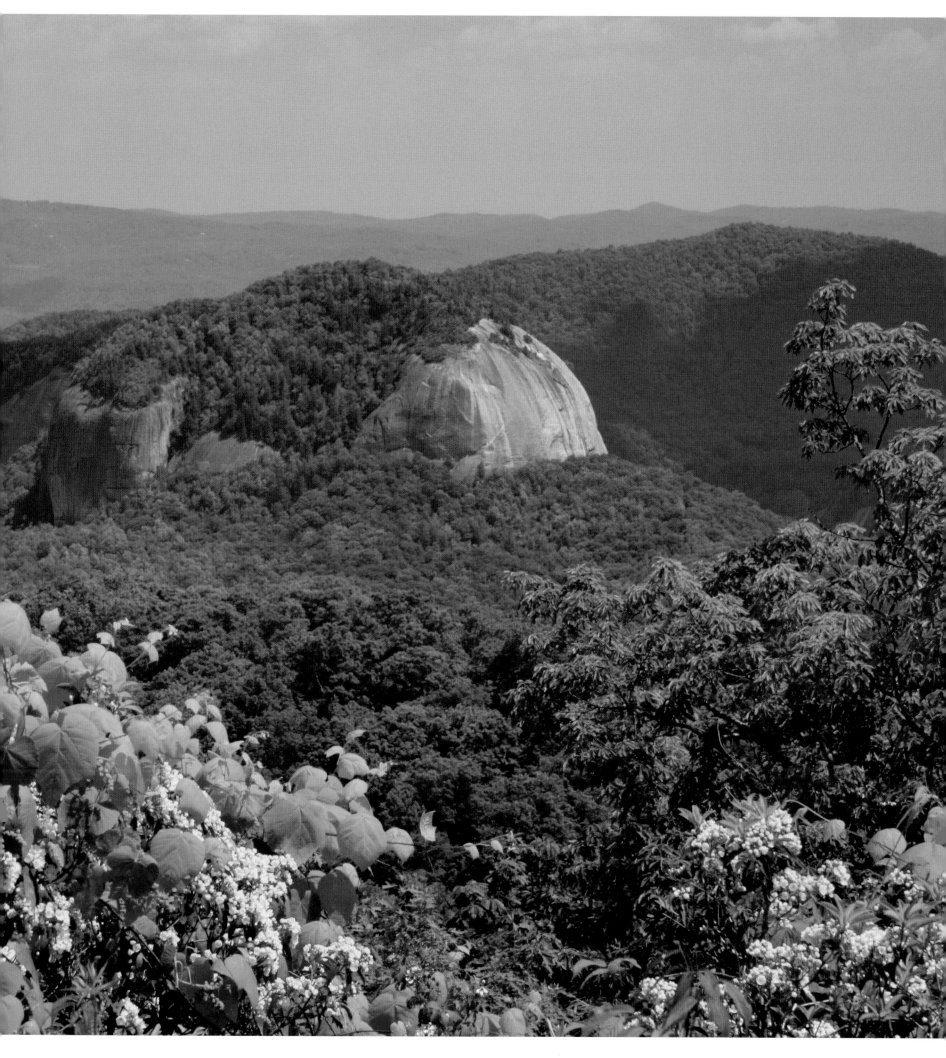

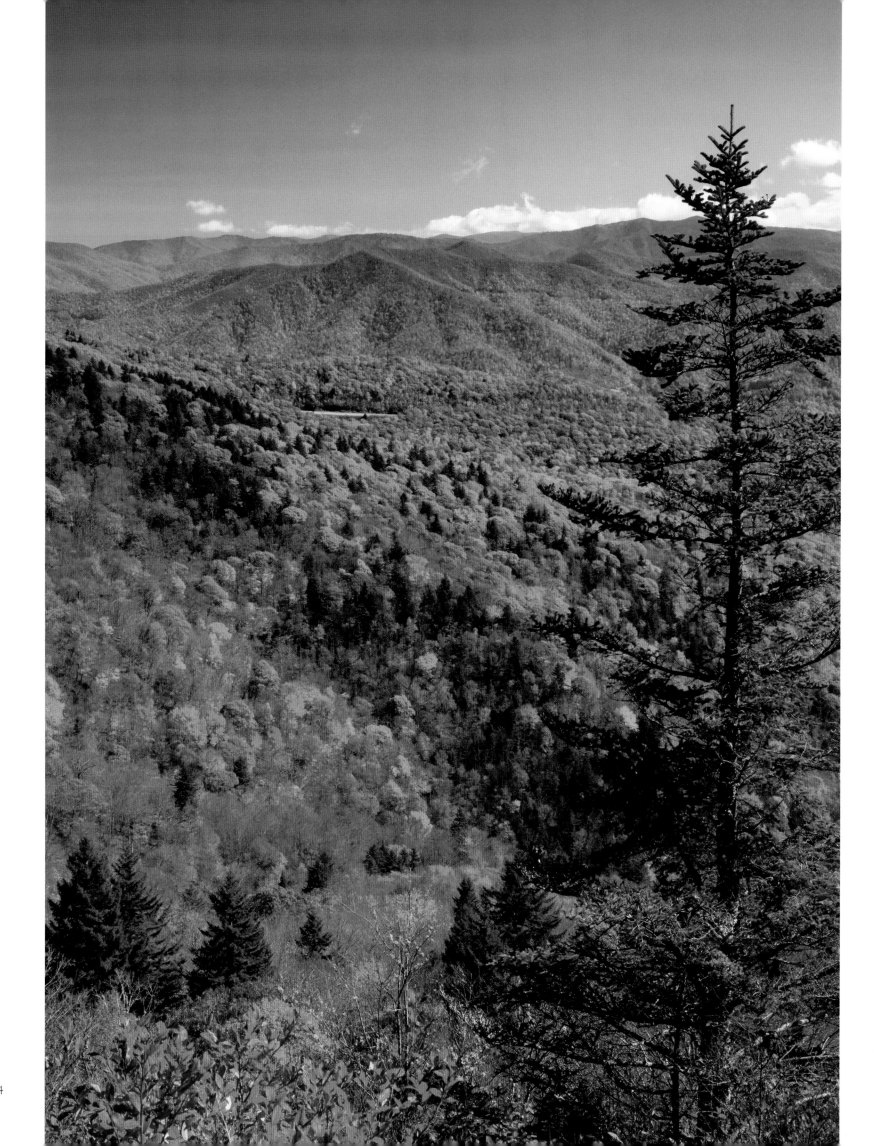

Facing page: Waterrock Knob in North Carolina is the second-highest point on the Blue Ridge Parkway, its 0.6-mile trail reaching an elevation of 6,400 feet. Fir trees and other hardy species survive cold weather at this height, which is closer to that of northern latitudes than of the mountain south.

Below, left: October means fall harvest in small towns along the parkway, including Meadows of Dan in Virginia. Another road of significance, the Crooked Road—which follows a geography of mountain music through southwest Virginia—also passes by here.

Below, right: Early pioneer life is re-created and remembered at Humpback Rocks, less than six miles from the northern terminus of the Blue Ridge Parkway. Most of the buildings date from the 1880s and were moved here from their original sites.

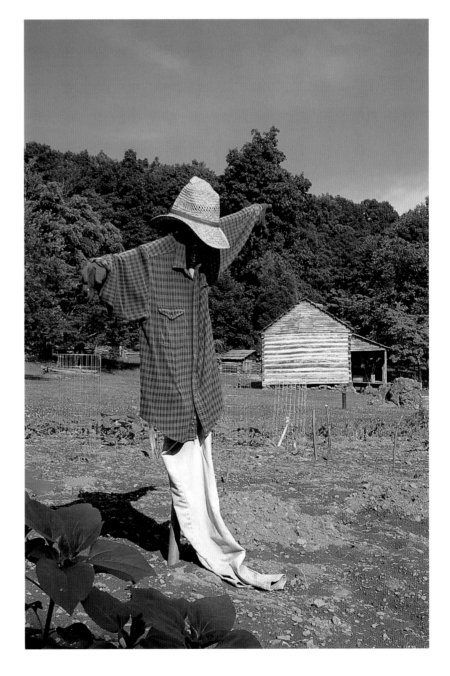

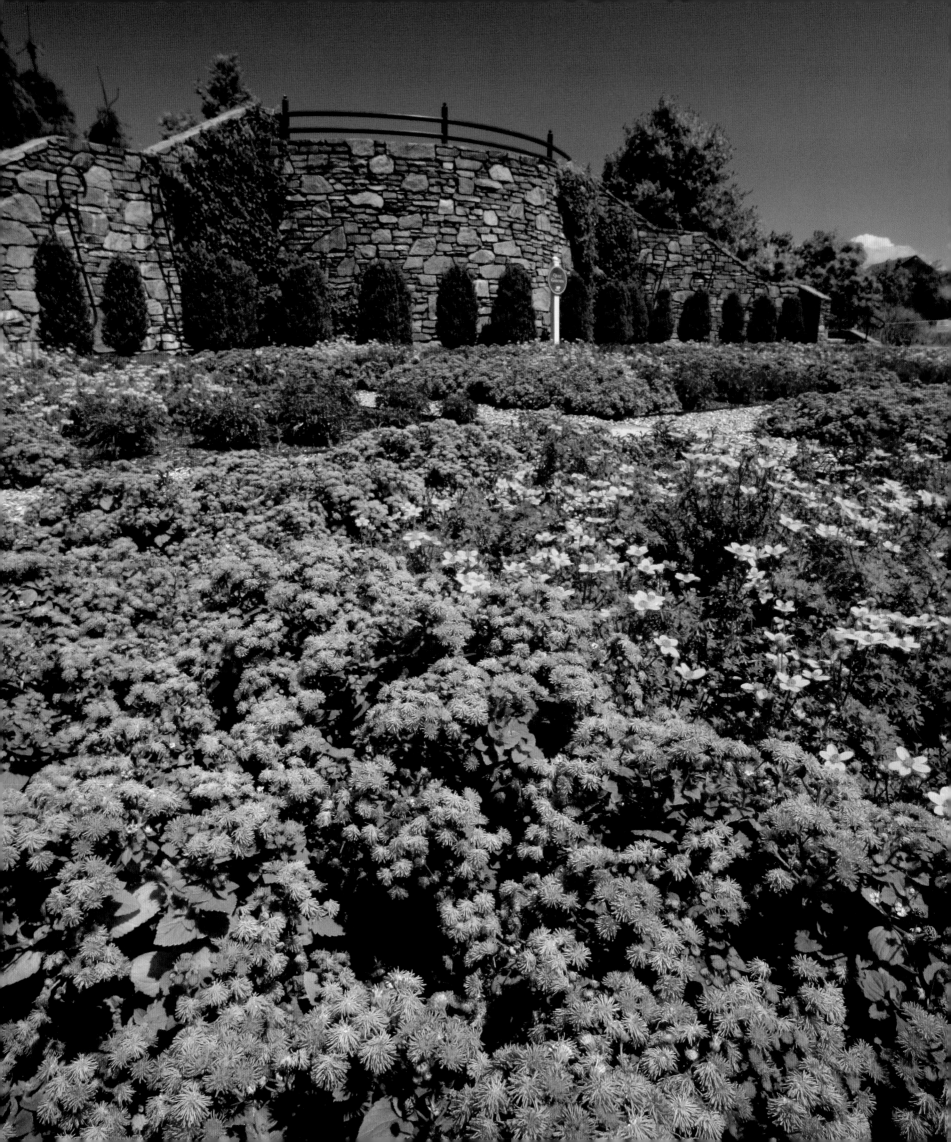

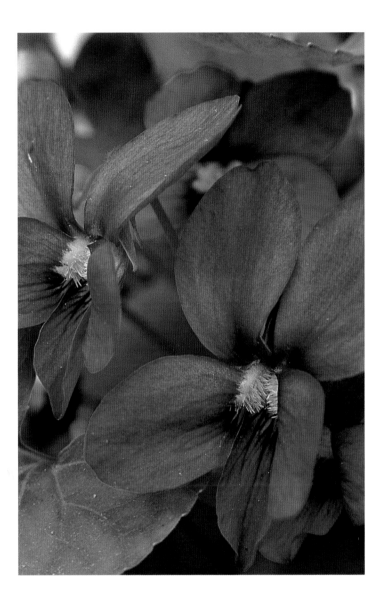

Above, left: Ferns come from old stock, ancient plant groups from when these mountains first formed. They're found in moist soil and reproduce by sending spores aloft. Of a number of varieties found along the parkway, royal ferns can grow more than five feet in height.

Above, right: A variety of violets bloom along the Blue Ridge Parkway, beginning in April.

Facing page: The North Carolina Arboretum, in Asheville, is no ordinary arboretum. Part of the Pisgah National Forest, the 434-acre arboretum has multiple gardens, including a collection of bonsai cultivated from native and nonnative trees, and a garden planted in different quilt patterns.

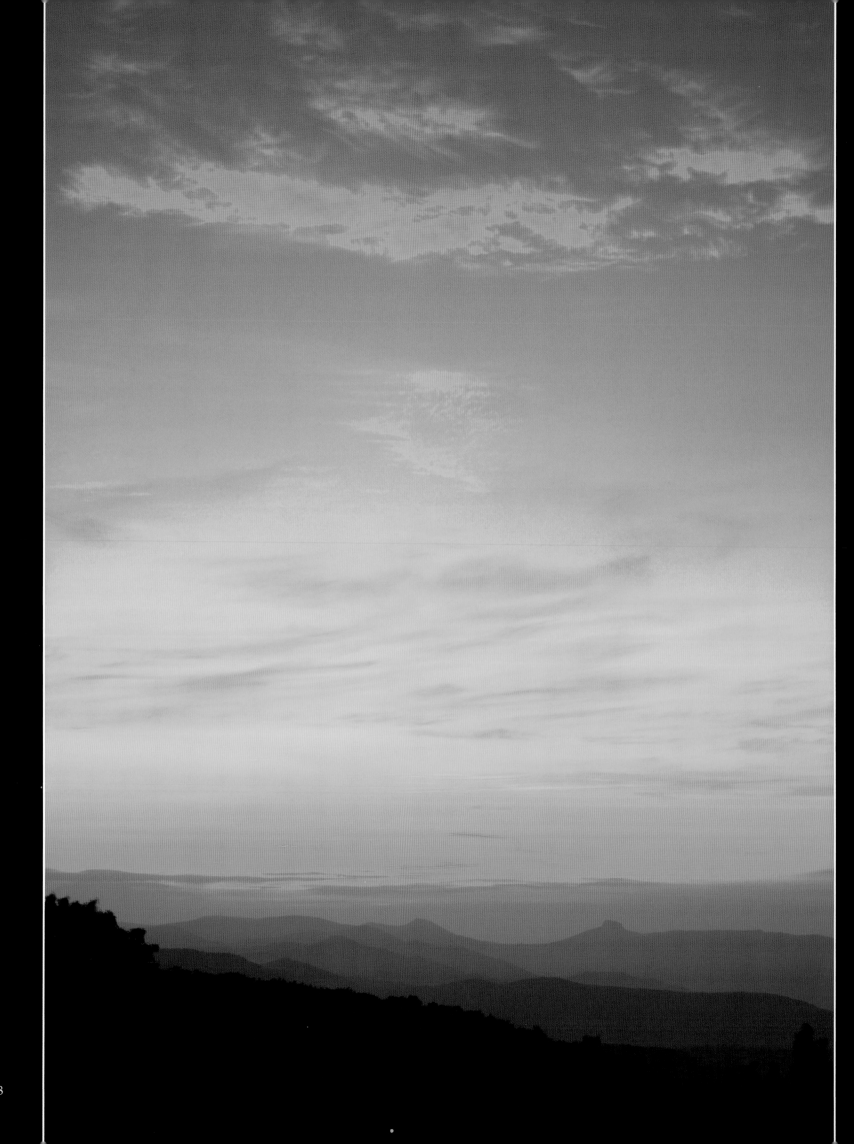

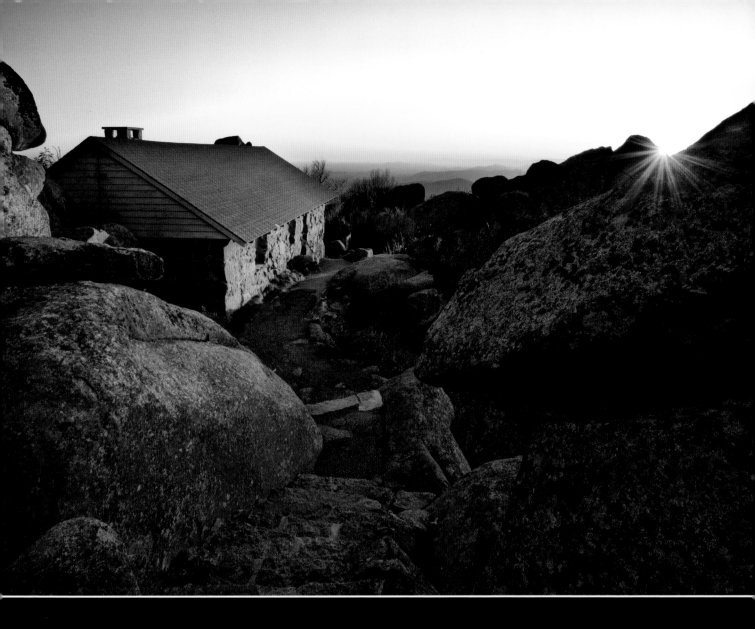

Above: The trail to the shelter at the summit of Sharp Top, at Virginia's Peaks of Otter, climbs 1,400 feet in one and a half miles, ending in a 360-degree view that includes the line of parkway to the north and south.

Left: The Blue Ridge Music Center's hillside amphitheater is alive with music summer and fall weekends. The center, with stage, hiking trails, and museum, is just outside Galax, Virginia.

Facing Page: The faint glow of sunrise touches the ridges around Crabtree Meadows in North Carolina. The area was once known as the Blue Ridge Meadows.

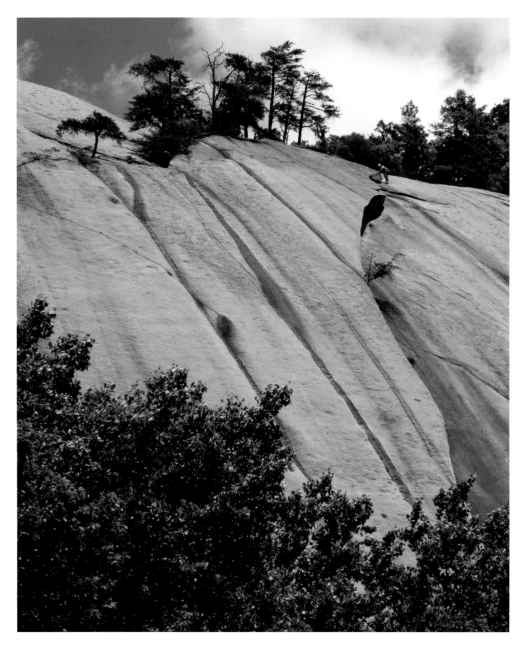

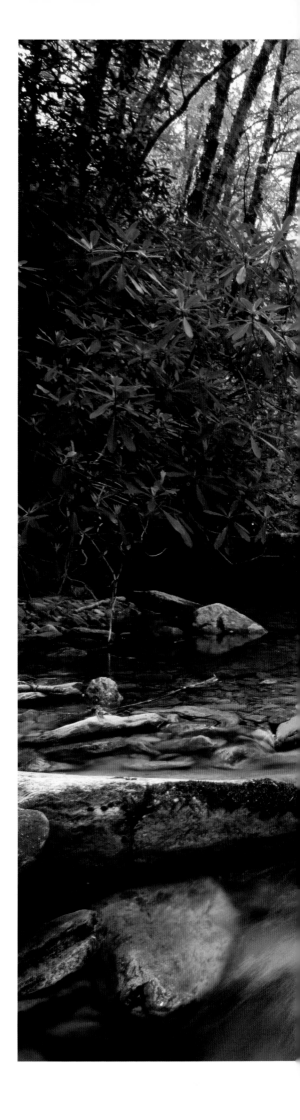

Above: Hardy ferns, lichens, cedars, and pines grow on the striking 600-foot granite face of Stone Mountain (elevation 3,879 feet), part of the 13,000-plus-acre Stone Mountain State Park in North Carolina. (Note the climber at the top right of the stone face). At milepost 232.5 is a wayside exhibit about the mountain.

Right: The Boone Fork Bridge is one of several wooden and steel spans that cross streams along the Tanawha Trail in North Carolina. More than half the trail lies on Grandfather Mountain's southeastern slope. The Cherokee called the mountain Tanawha, meaning "fabulous eagle."

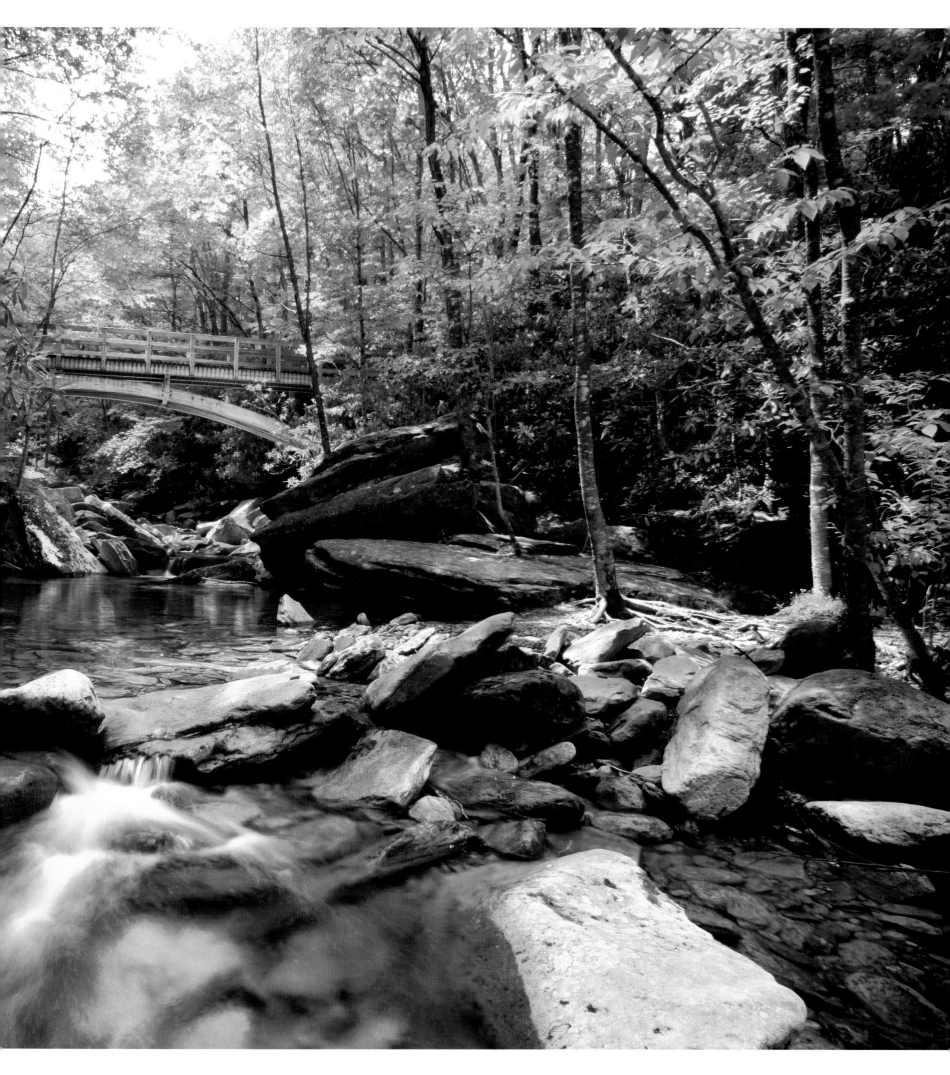

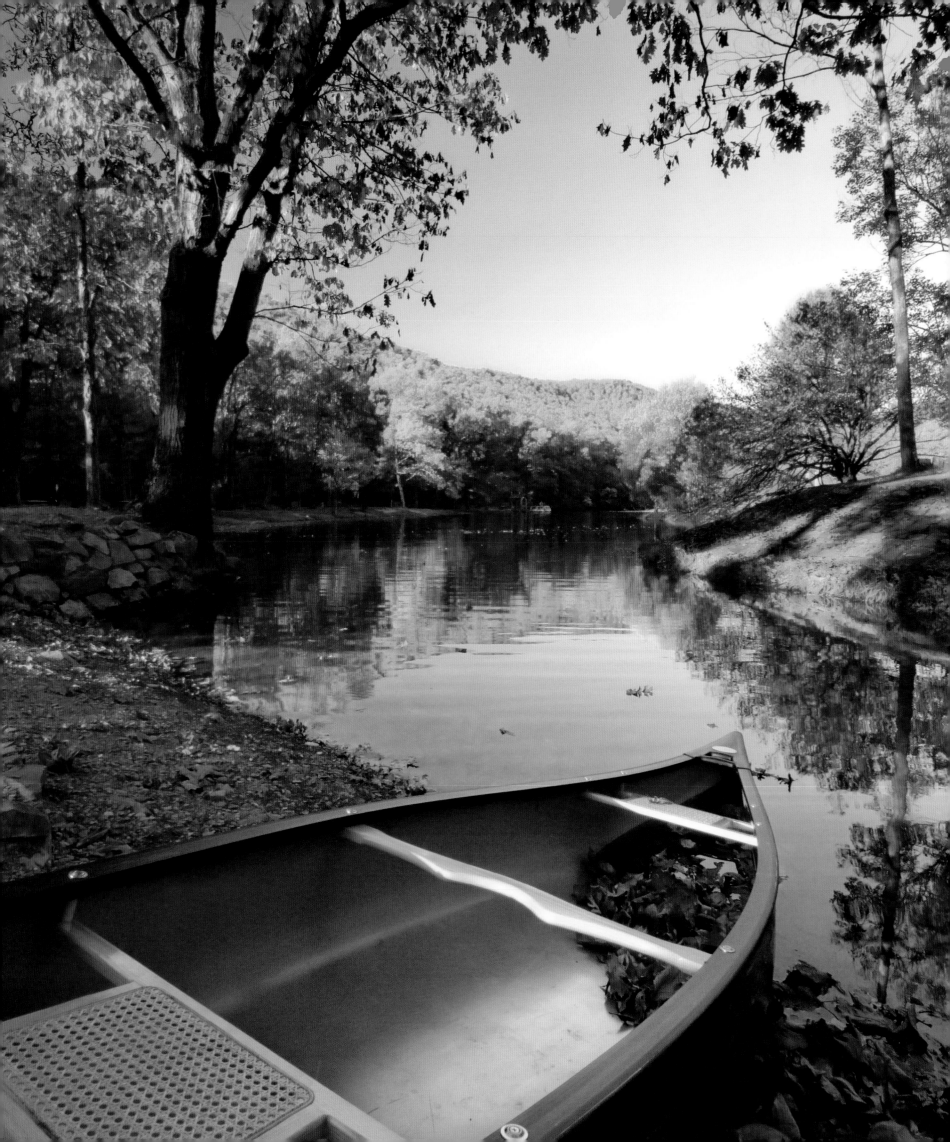

Facing page: A canoe waits for its next fishing trip, while trees in their fall finery glow along Sherando Lake. Its waters cover twenty-two acres in Virginia.

Below: At milepost 162.4 lies Rakes Mill Pond, once a source of cornmeal (the mill was owned by Jarmon Rake) and speckled trout for area residents.

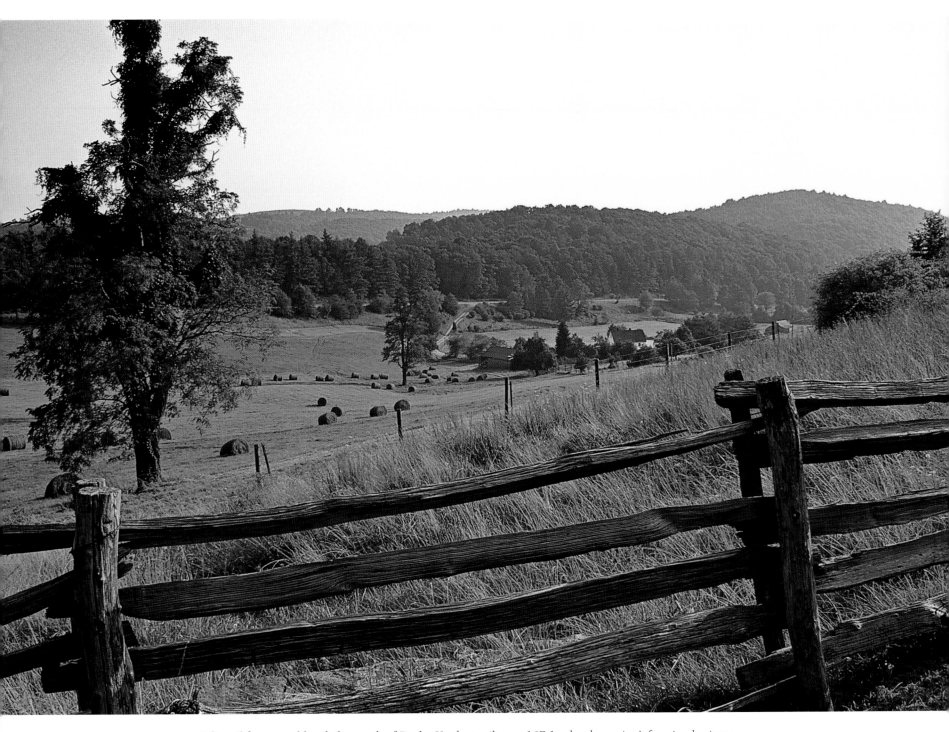

Above: Split-rail fences and hay bales south of Rocky Knob at milepost 167.1 echo the region's farming heritage.

Facing page, top left: Little Glade Mill Pond, at milepost 230.1, offers a short hike and picnic tables.

Facing page, top right: Flame azalea blooms in North Carolina's Craggy Gardens. A hike along the Craggy Gardens Trail brings visitors to a mountain bald brightened by another high-elevation flower, the rhododendron.

Facing page, bottom: The cascades at E. B. Jeffress Park, at milepost 271.9, are seen through autumn leaves along a walking trail.

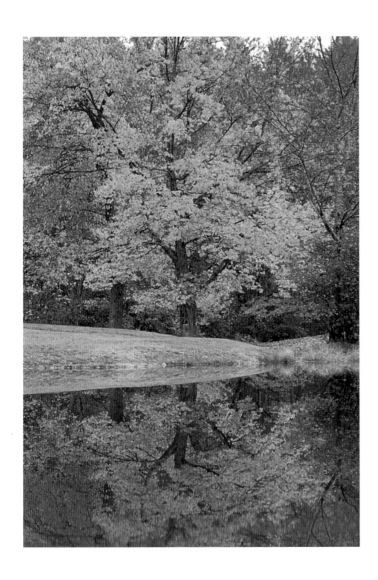

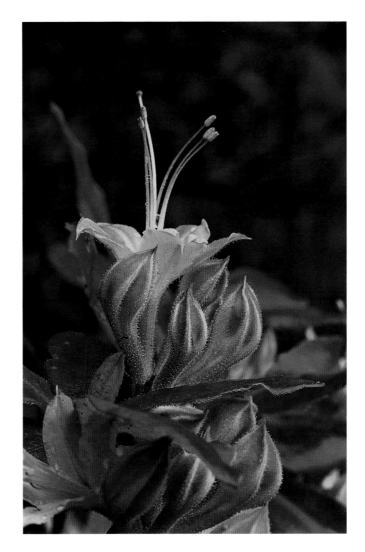

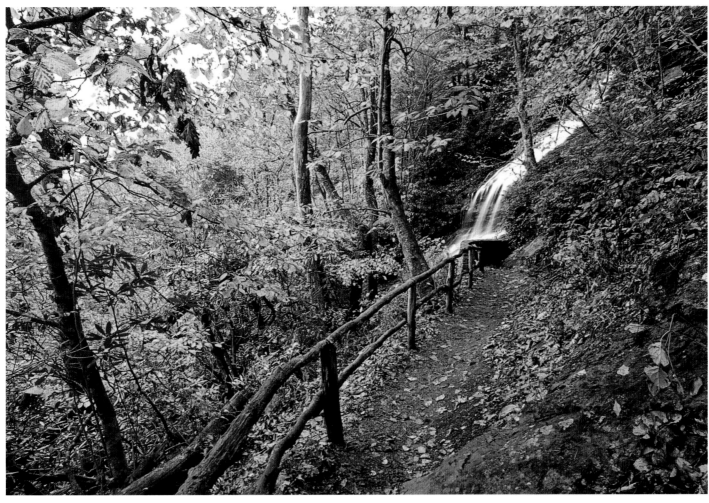

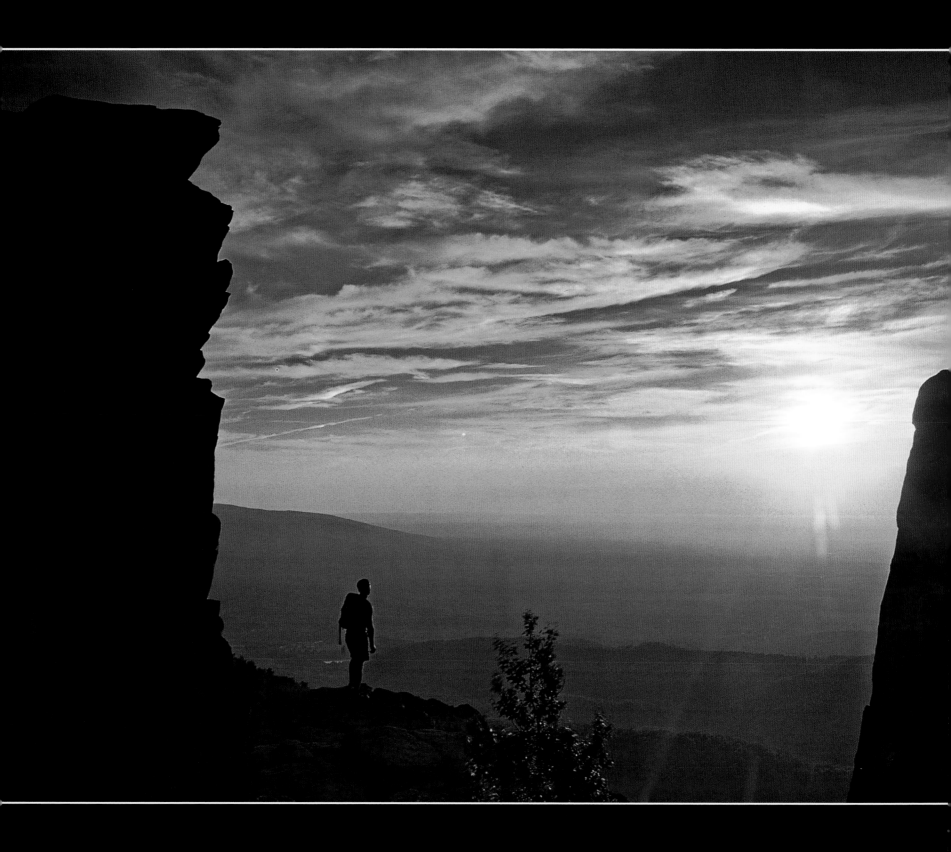

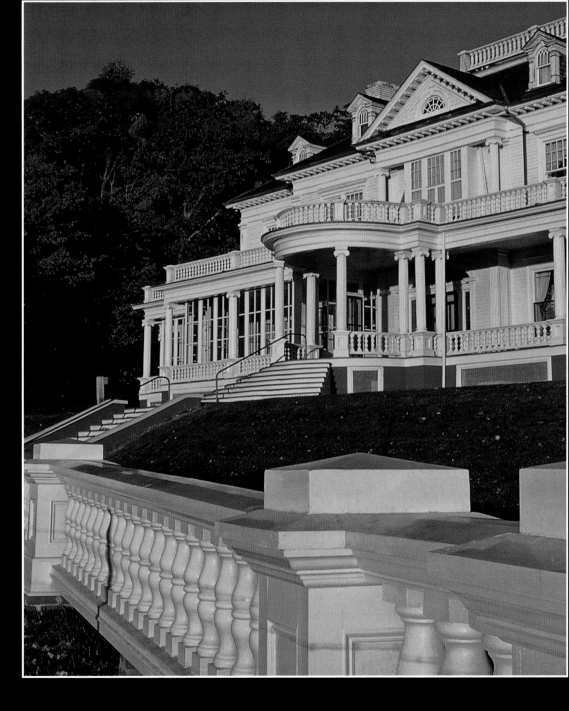

Above, top: "Denim King" Moses H. Cone bought 3,500 acres in North Carolina and built Flat Top Manor in the 1890s. Since 1950, the estate has operated as the Moses H. Cone Memorial Park.

Left: George Vanderbilt constructed the Biltmore Estate in Asheville, North Carolina, in the 1890s. Today, more than a million people visit the estate each year. It's still a working farm and winery, with extensive gardens and greenhouses that grow plants from the everyday (such as these mums) to the exotic.

Far left: The Appalachian Trail passes by here at Humpback Rocks (milepost 6). The rocks were a landmark along the Old Howardsville Turnpike until the coming of the railroad in the late nineteenth century.

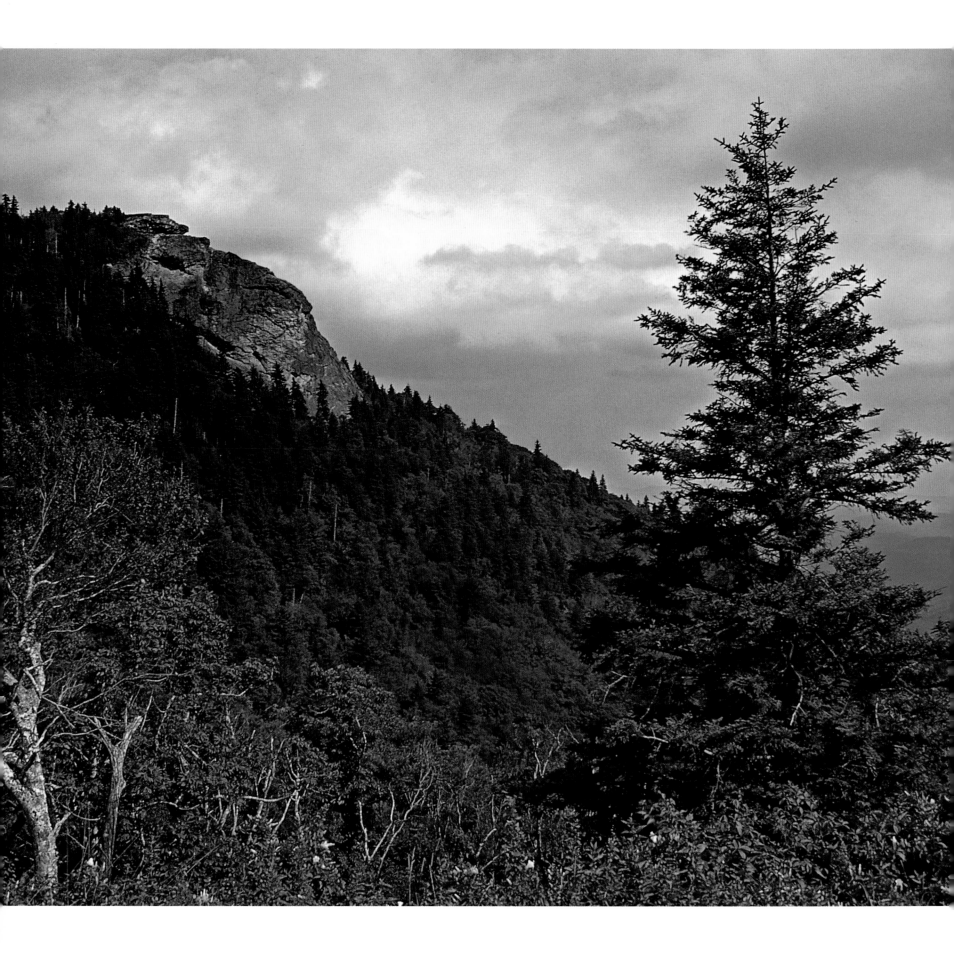

Left: For the Cherokee, this imposing stone tower was the seat of the evil spirit Judaculla; today it's known as Devils Courthouse. A short but steep hike through fir and spruce trees ends in a beautiful view and a good spot for hawk watching.

Below, top: Eastern box turtles can be found along the parkway up to an elevation of approximately 4,500 feet. They're most active in June and early July, when laying eggs.

Below, bottom: Cottontail rabbits are common along the Blue Ridge Parkway. Two species live in the region: the more familiar eastern cottontail and the New England cottontail, which lives in high elevations (3,000 feet and up) in Virginia and North Carolina.

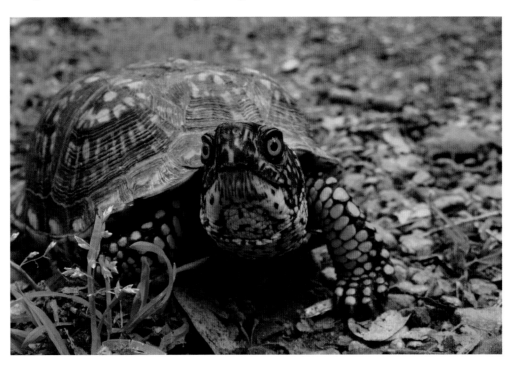

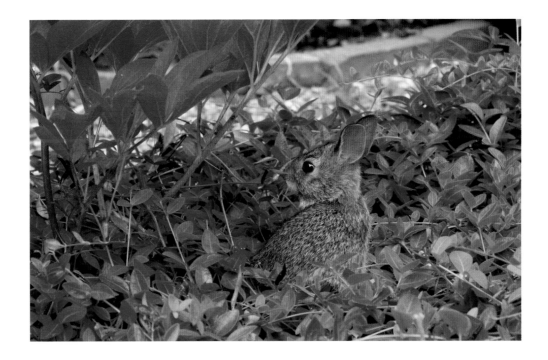

Right: It's just a short hike to Flat Rock, at milepost 308.3, for this sunset view of Grandfather Mountain.

Below: The fretted dulcimer (this one photographed at the Humpback Rocks interpretive center) has been known as the mountain, Appalachian, or Kentucky dulcimer and, even earlier, the hog fiddle, music box, and harmony box. It evolved from European instruments in the eighteenth and nineteenth centuries. (The hammered dulcimer, a different instrument, had its earliest roots in Asia.)

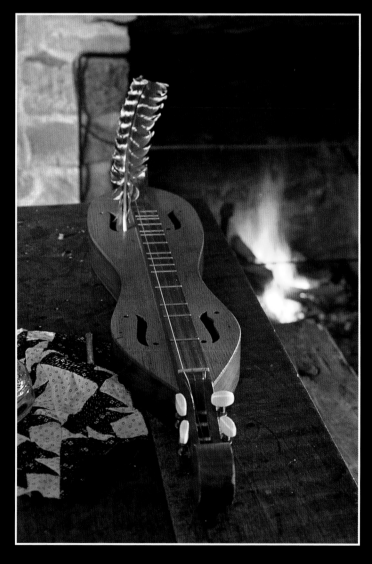

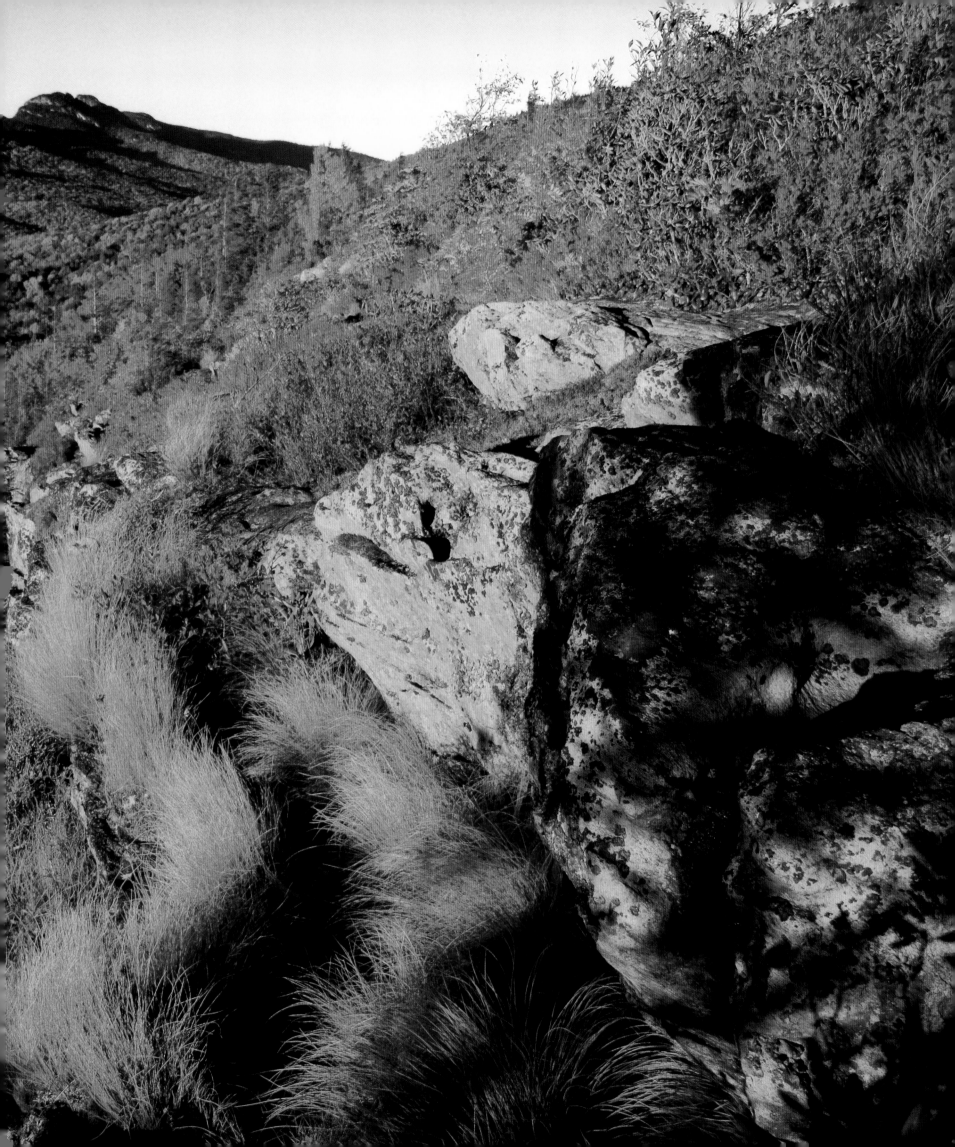

Right: The sun rises over the Orchard at Altapass in North Carolina. The Clinchfield Railroad gave this area its name—meaning "high" pass—and planted the orchards. When the parkway was built, it split the orchard. The current owners purchased the orchard in 1994 and soon after began its restoration.

Below, top: Mabry Mill is known for its buckwheat flour, stone-ground grits, and cornmeal.

Below, bottom: Trinity Episcopal Church in Glendale Springs, North Carolina, is the home of *The Last Supper,* a fresco painted by artist Ben Long in 1980.

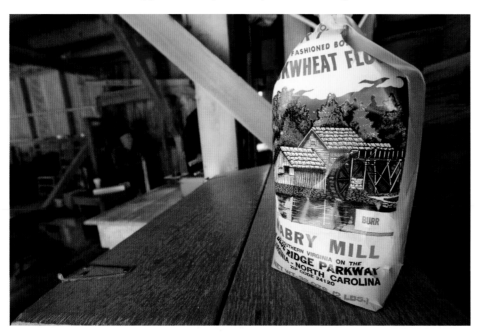

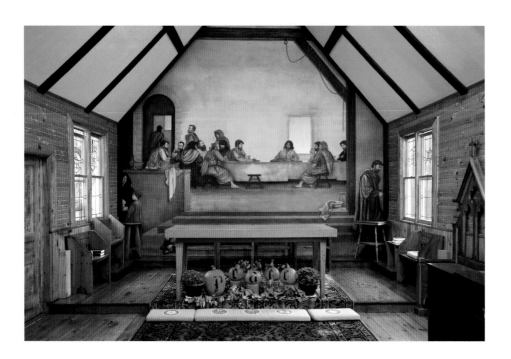

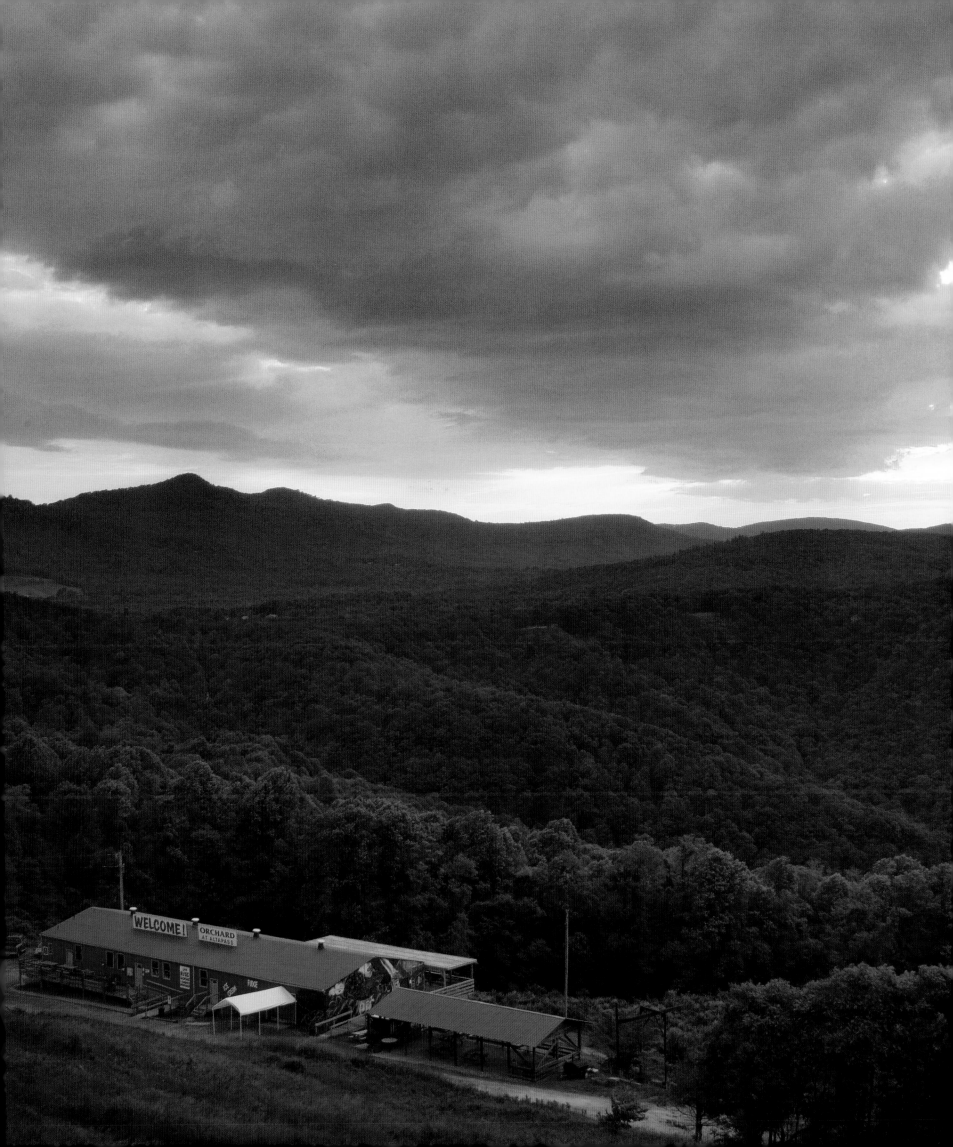

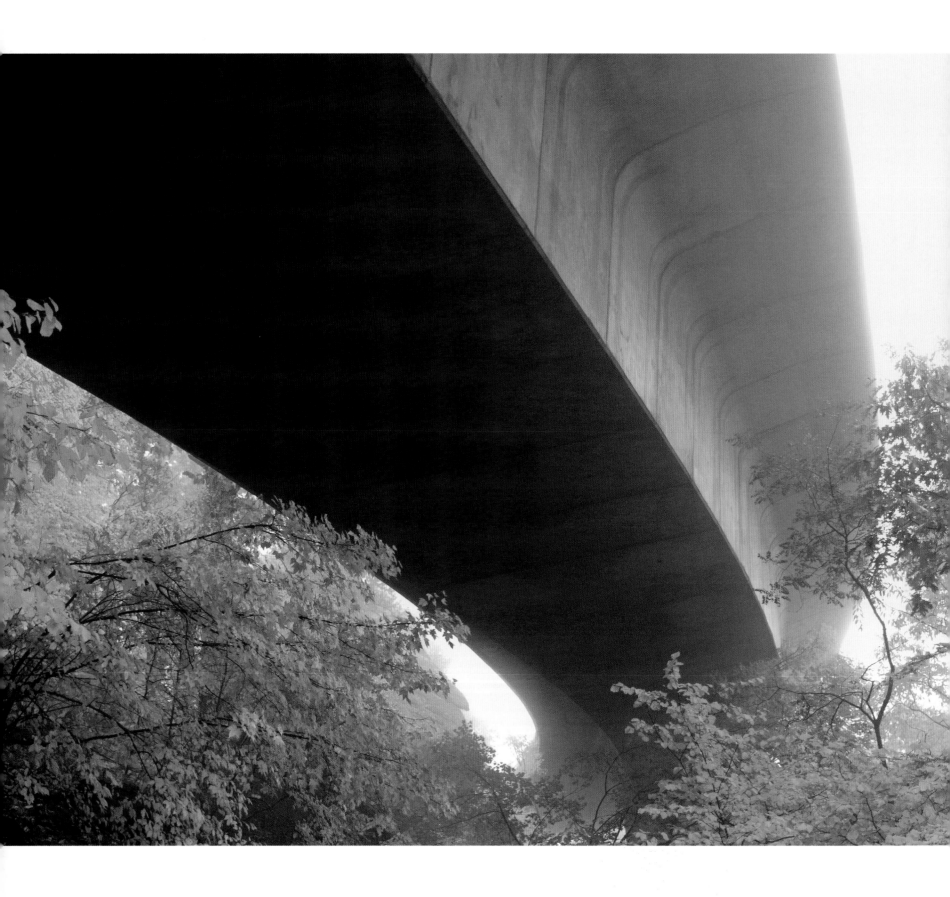

Left: Black-eyed Susans raise their yellow heads in meadows from June through October.

Far left: At the time, the Linn Cove Viaduct was a unique feat of engineering. Curving around Grandfather Mountain in North Carolina, this section was the last to be completed along the Blue Ridge Parkway, in 1987.

Below: Autumn leaves create both canopy and floor in the Buck Creek area of North Carolina, near milepost 344.

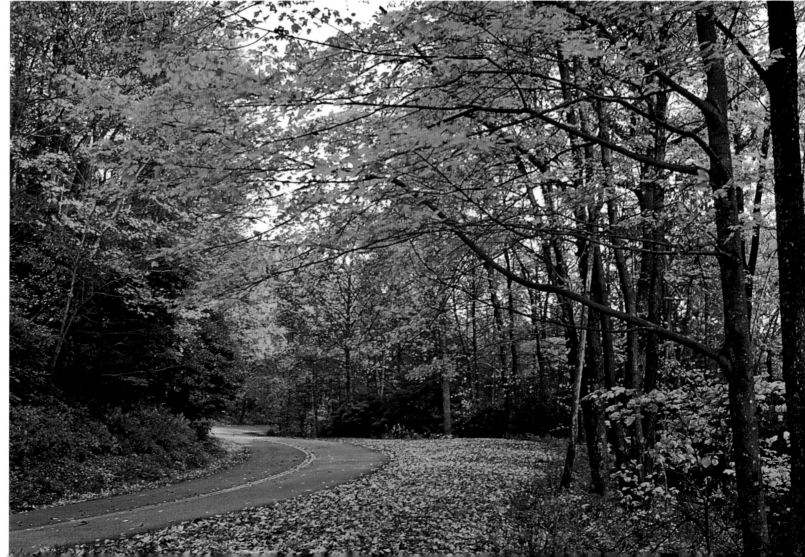

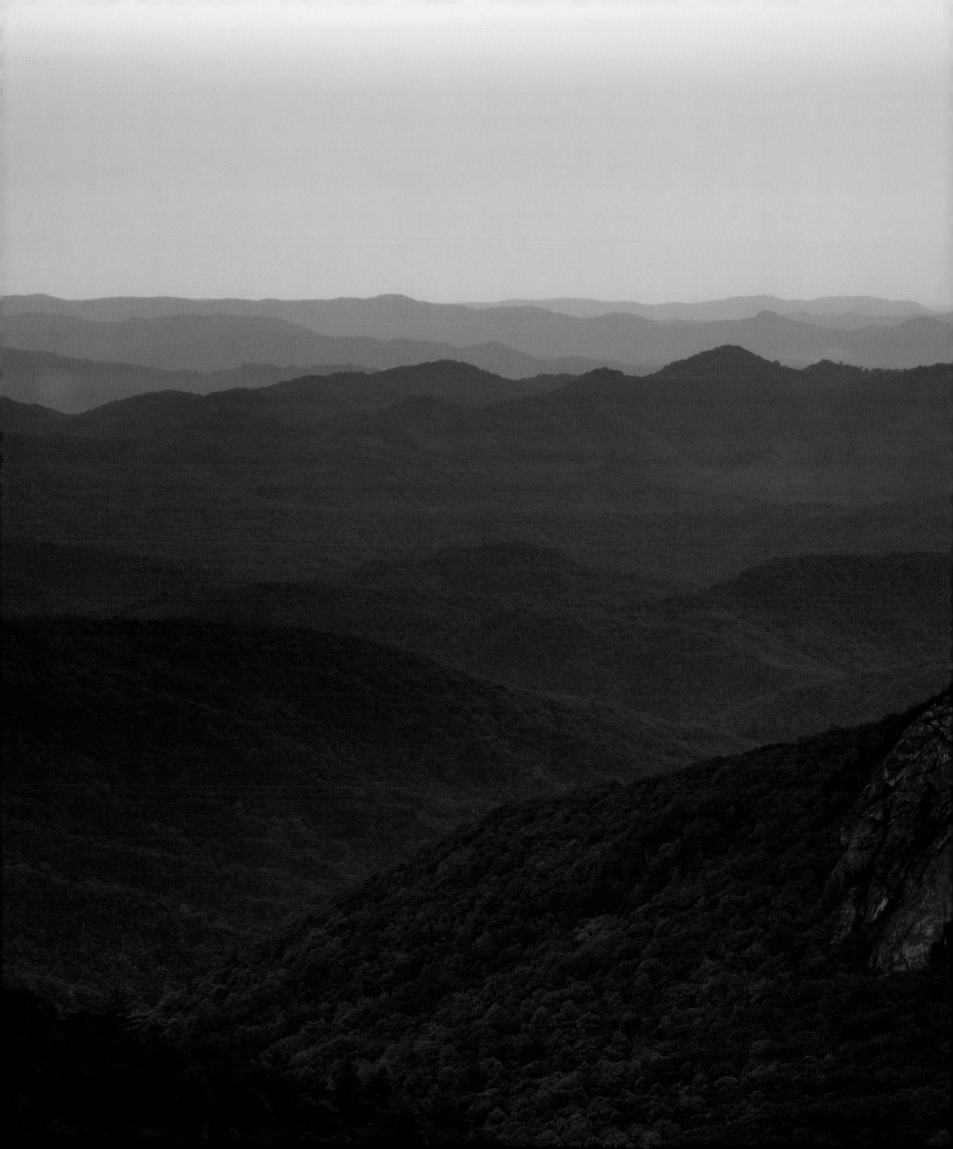

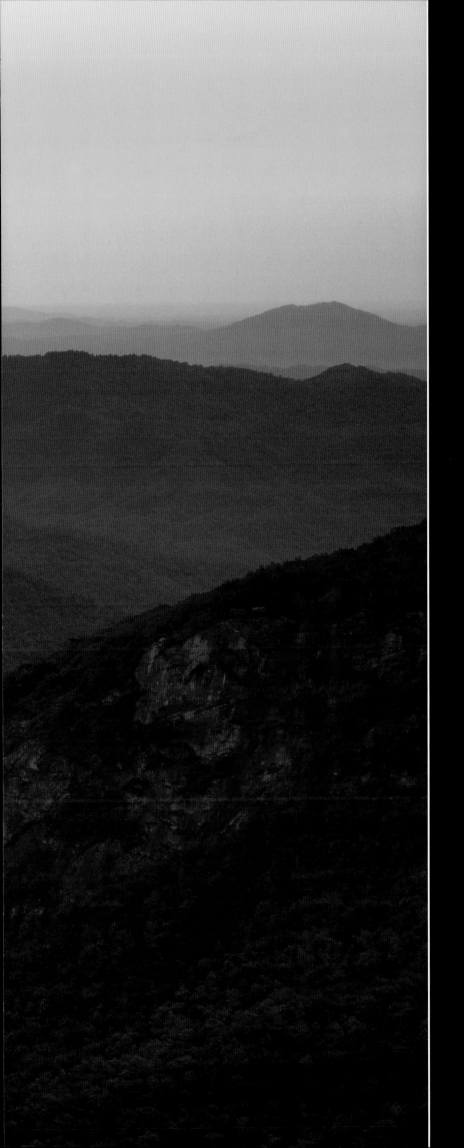

Left: A June sunrise turns the ridges in the Linville Falls area deep purple. The river and the falls are named for William Linville, who died with his son during an attack by Native Americans while hunting in 1766.

Below: Blacksmith Will Foster makes sparks while demonstrating his traditional craft at Mabry Mill.

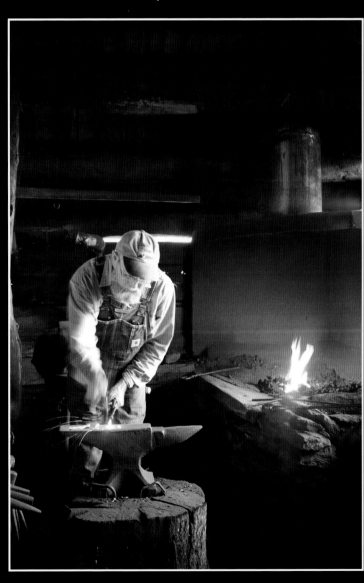

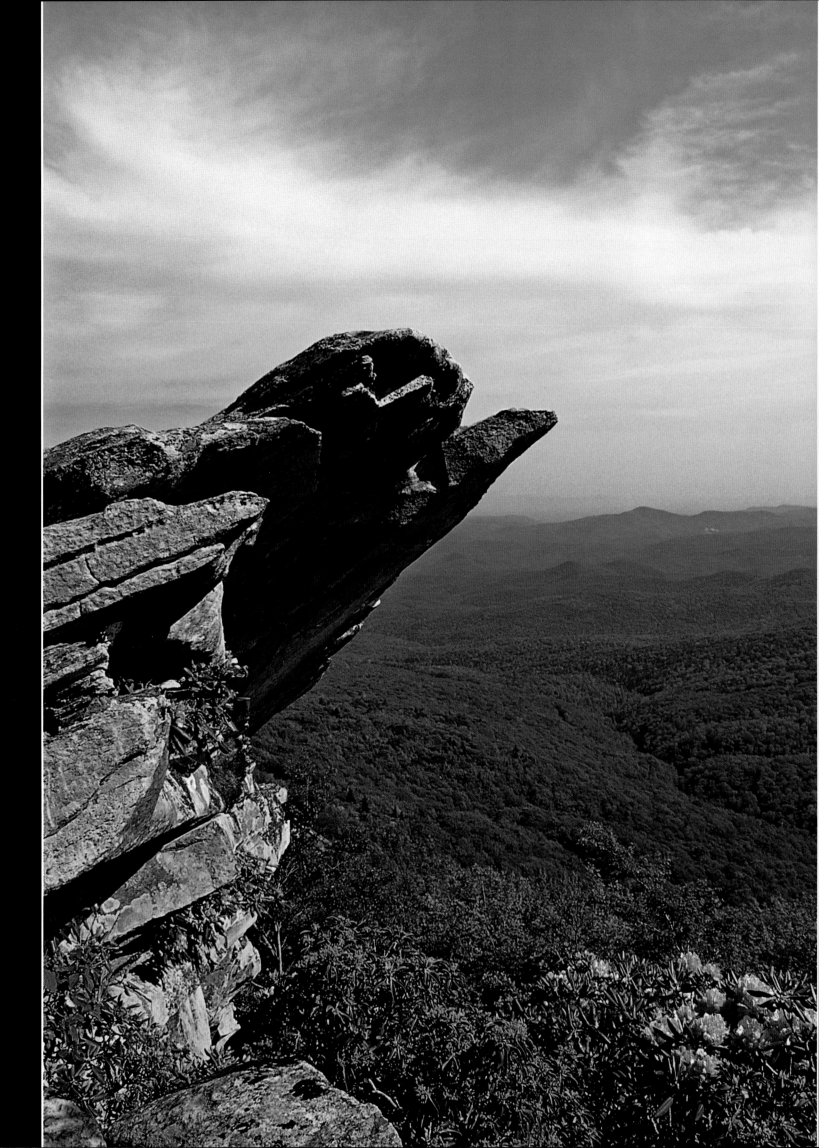

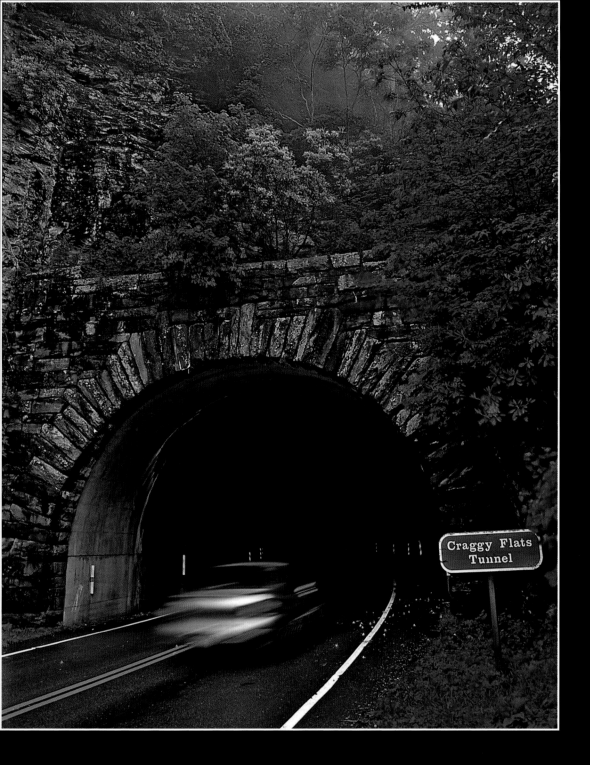

Above: A car heads into Craggy Flats Tunnel, at milepost 365.5. It's one of twenty-six tunnels on the parkway; twenty-five of them are in North Carolina.

Right: Rhododendron blooms along the Appalachian Trail at Onion Mountain in June (a nearby overlook is at milepost 79.7).

Facing page: The Tanawha Trail at Grandfather Mountain traverses terrain reminiscent of New England latitudes. Rough Ridge is one of the rugged landmarks along the trail.

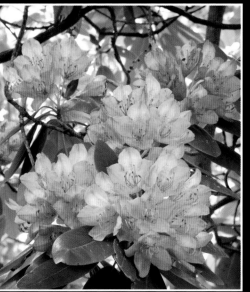

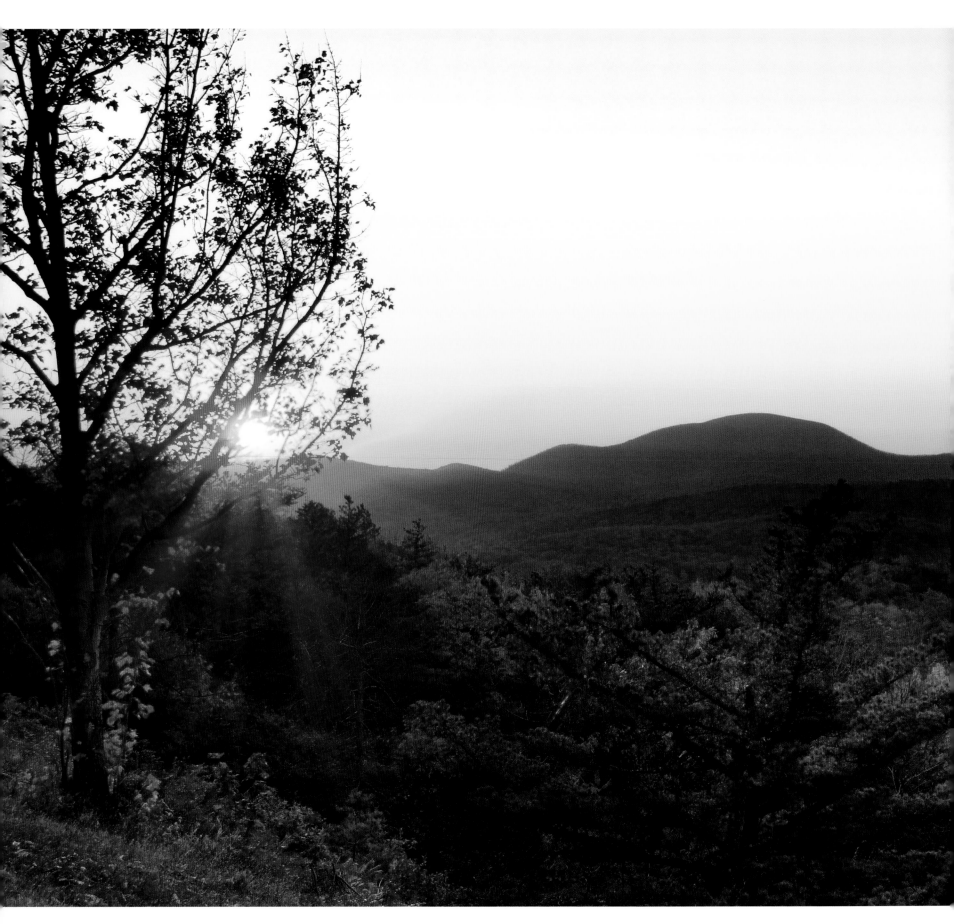

Dawn breaks at the Tye River Gap in Virginia, near milepost 27.2.

Facing Page: Take a seat and enjoy the view at Moses H. Cone's Flat Top Manor, named for nearby Flat Top Mountain.

Below, left: Mountain laurel grows next to the tumbled rocks of a hog wall, a remnant of the region's agricultural heritage.

Below, right: Near Humpback Rocks, close to the northern terminus of the parkway, is the site of an 1867 farmstead that belonged to early settler William J. Carter.

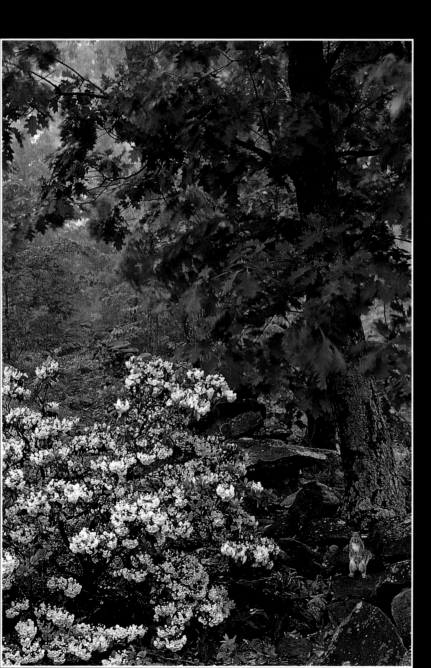

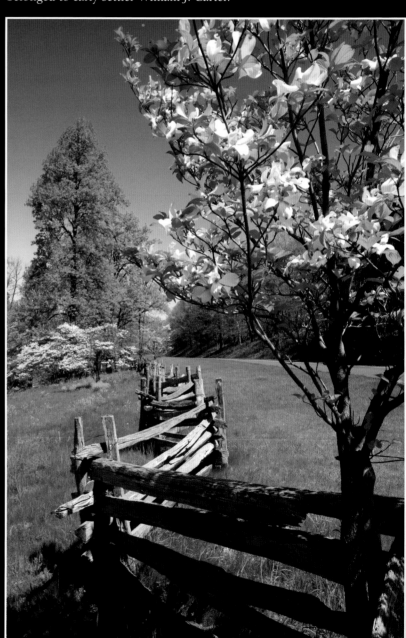

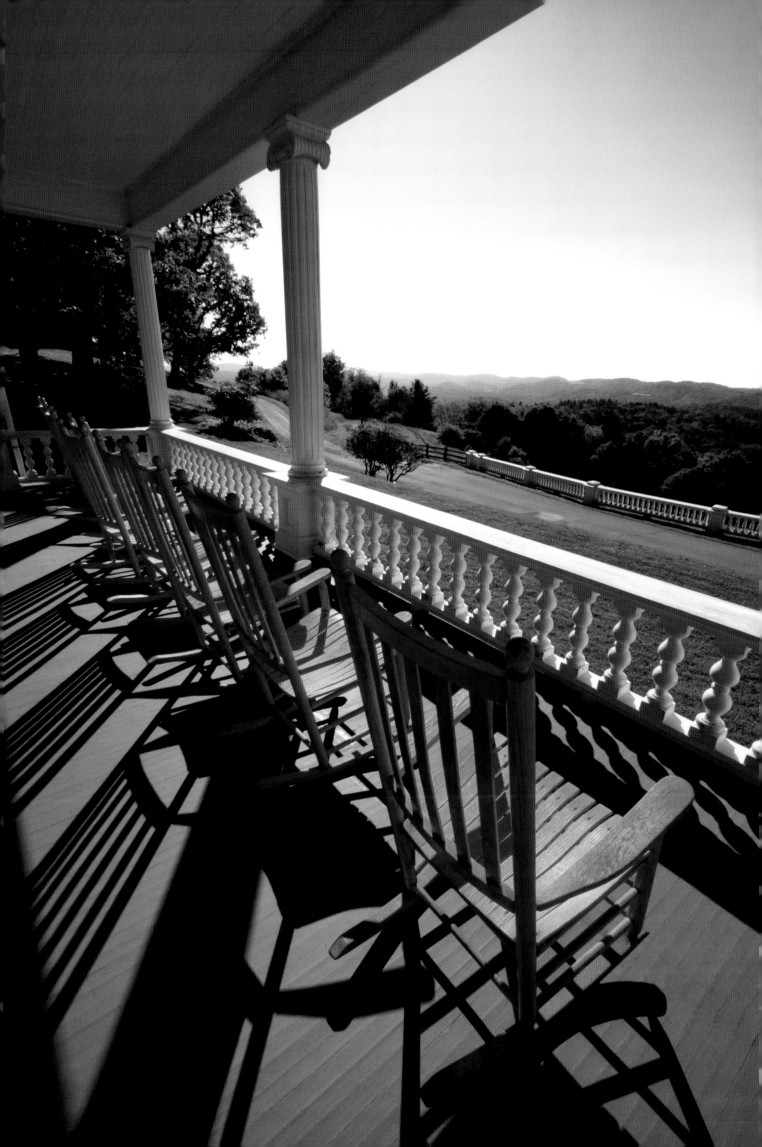

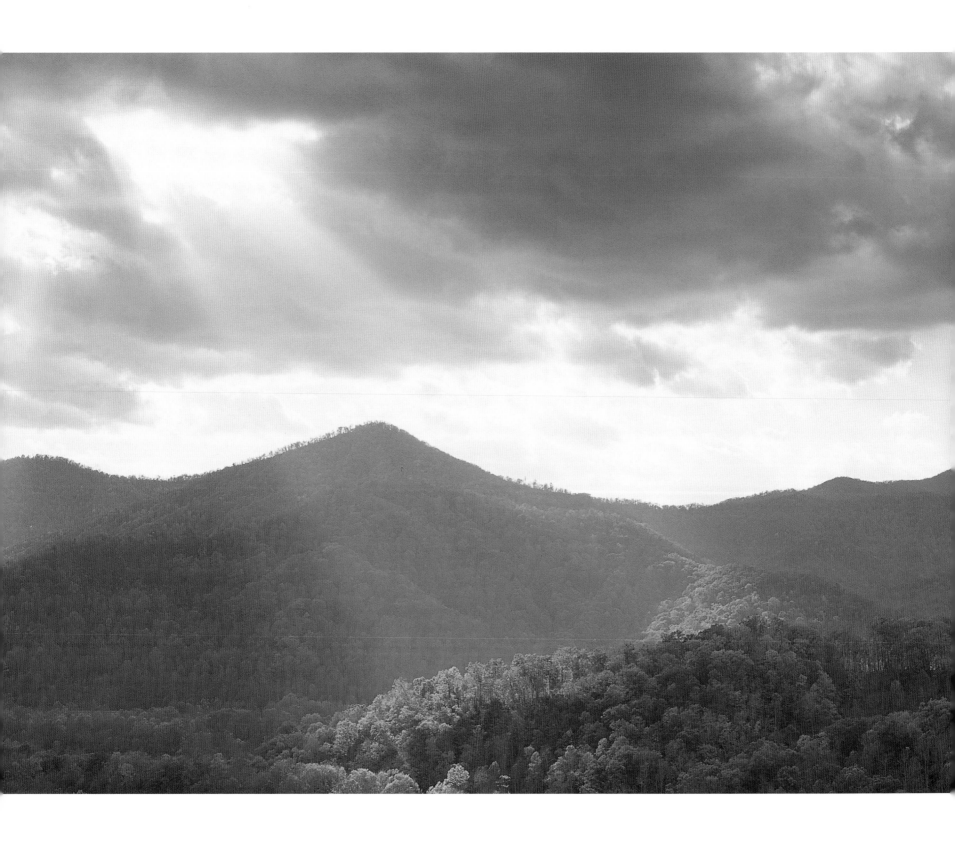

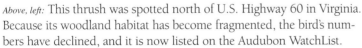

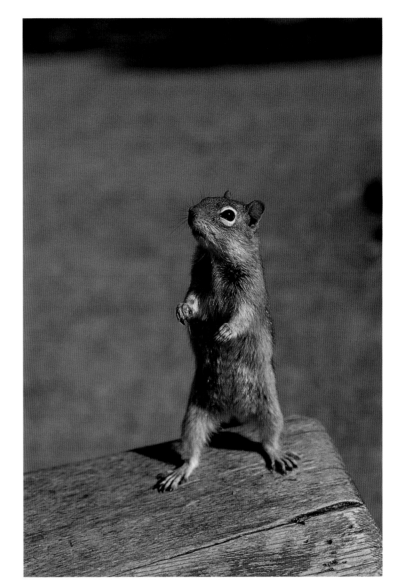

Above, left: This thrush was spotted north of U.S. Highway 60 in Virginia. Because its woodland habitat has become fragmented, the bird's numbers have declined, and it is now listed on the Audubon WatchList.

Above, right: The chipmunk is a familiar inhabitant of the Blue Ridge Parkway. Visitors may hear its warning "cluck" before they see it.

Left: Light breaks through the clouds in this view of Great Smoky Mountains National Park from the Blue Ridge Parkway. The parkway's 469 miles connect the Great Smokies with Virginia's Shenandoah National Park and Skyline Drive.

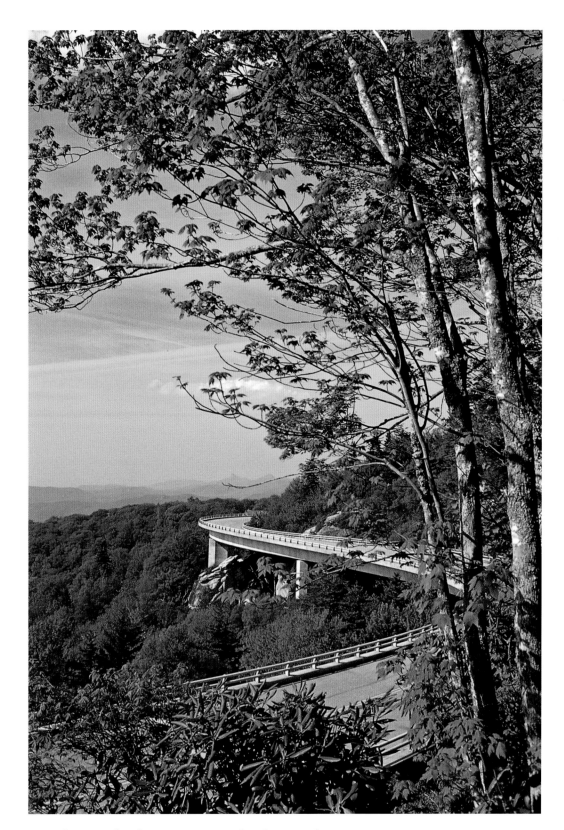

Above: The 1,243-foot-long Linn Cove Viaduct bypasses the nature preserves on Grandfather Mountain at milepost 304.

Left: North Carolina's Linville Falls drops ninety feet into the twelve-mile-long Linville Gorge. The area is a lesson in natural history, with virgin hemlock forests and geological formations that date back hundreds of millions of years.

Facing page: Seventy-foot-tall Crabtree Falls is part of the Crabtree Meadows Recreation Area in North Carolina (milepost 339.5). There were several crabapple orchards here in the days before the parkway, and visitors can still find a few trees left in the meadows.

Below, left: The cardinal is the official bird of seven states, including Virginia and North Carolina.

Below, right: The black bear is the largest animal in the Blue Ridge and can weigh up to 400 pounds. Their diet includes wild cherries, crayfish, frogs, mushrooms, chipmunks, and more; they can also take a liking to human food, the result of which is dangerous for both humans and bears.

Below, bottom: A significant portion of the world's feldspar, a mineral used in making ceramics, comes from the mines of Spruce Pine, North Carolina. The Museum of North Carolina Minerals, at milepost 330.9, exhibits quartz, kaolin, and mica, too.

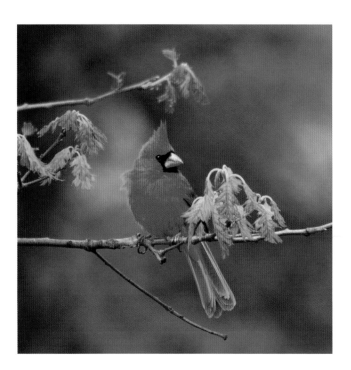

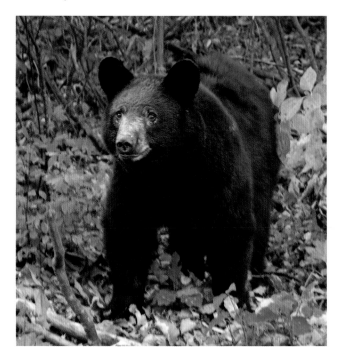

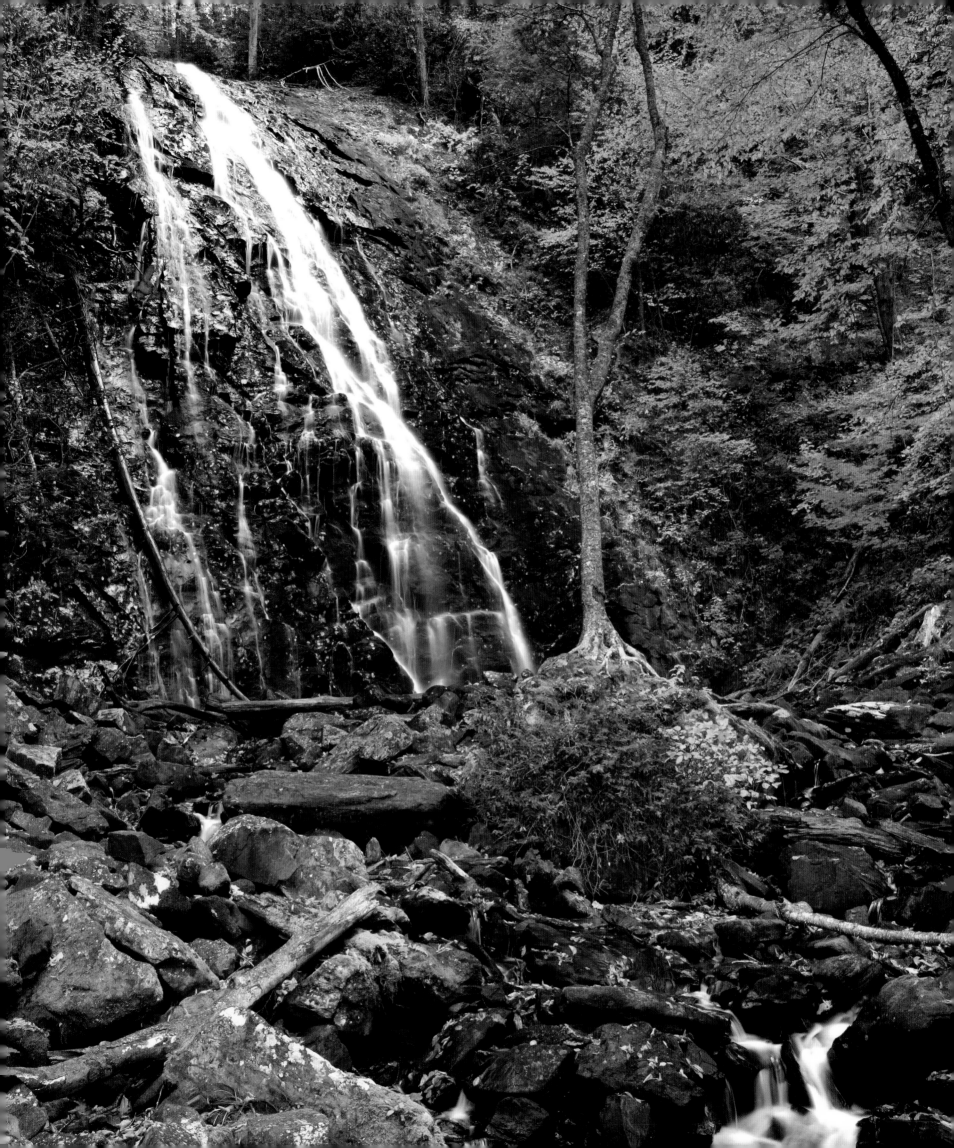

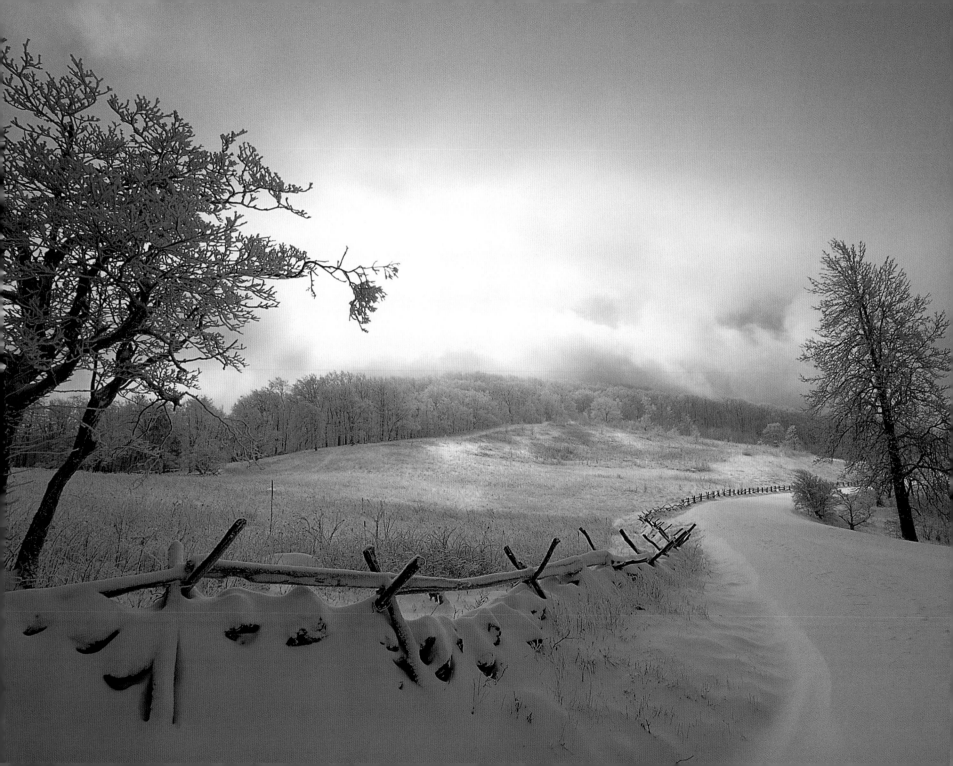

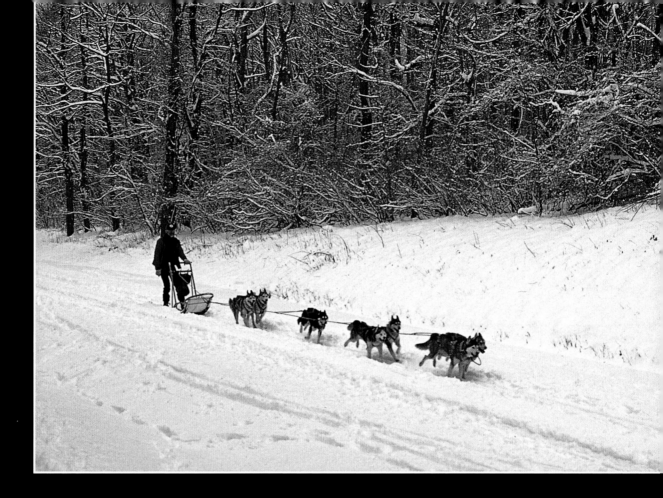

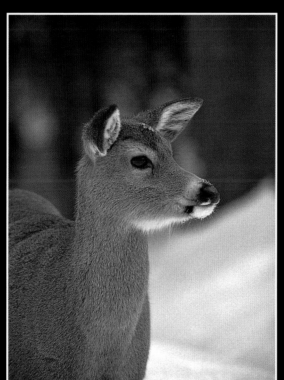

Above: When winter closes the parkway, dogsledding is another way to travel the road, here south of Rockfish Gap (the northern end of the parkway).

Left: Although common today, white-tailed deer nearly disappeared in the early twentieth century as the result of hunting, farming, and the lumber industry. In the years since, hunting restrictions and the relocation of deer to the area have restored their numbers.

Far left: The sun breaks through after a snowstorm at Humpback Rocks in Virginia.

Right: A ray of sunlight illuminates a patch of trees as they begin to change col-or in the Waterrock Knob area in October. The knob itself is 6,300 feet high and looks west to the Great Smoky Mountains and east to the Great Balsams.

Below: Twenty-five miles of carriage trails at Moses H. Cone Memorial Park in North Carolina draw both equestrians and hikers. Pictured are Bass Lake in the foreground and the Southern Highland Craft Guild's Parkway Craft Center in the background.

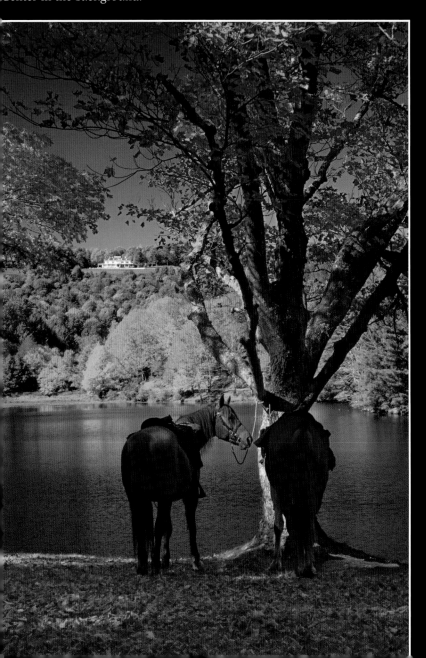

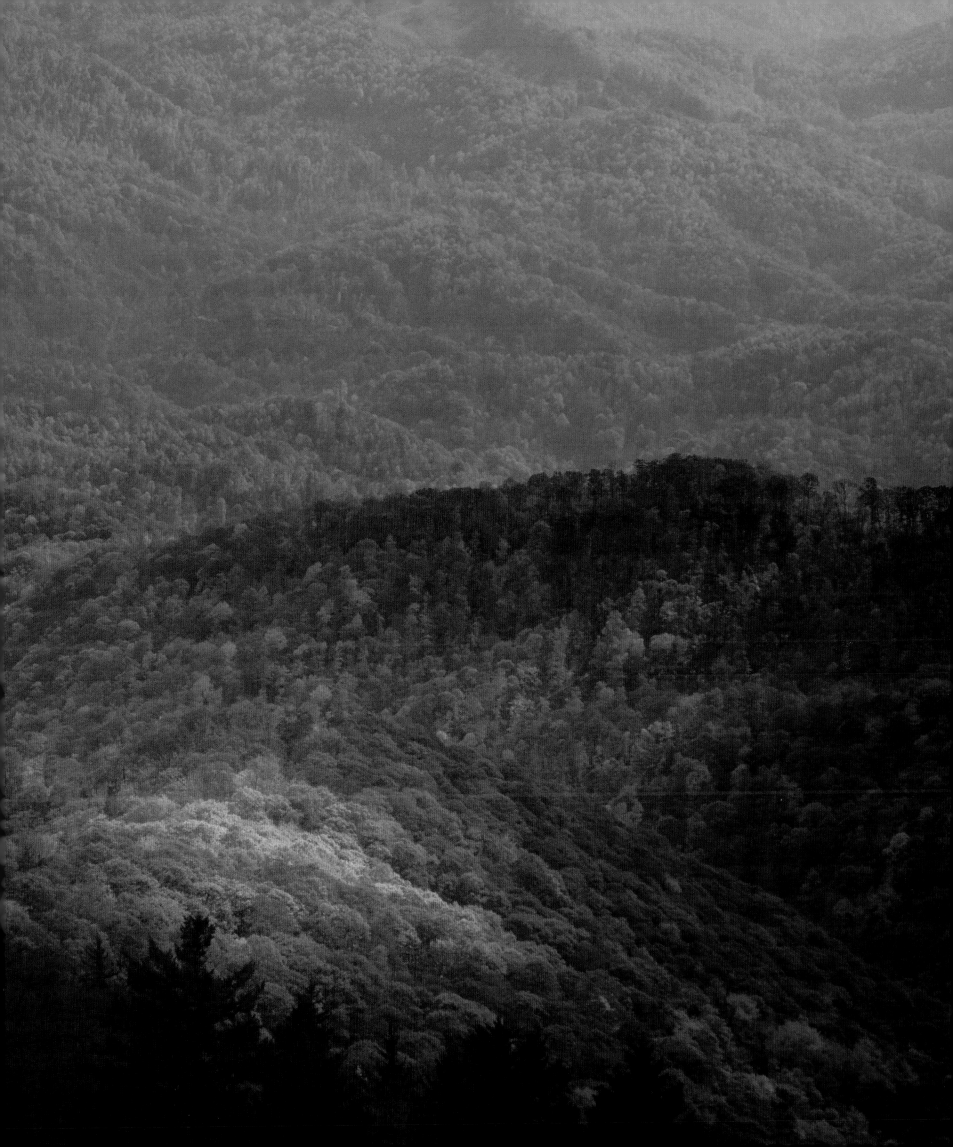

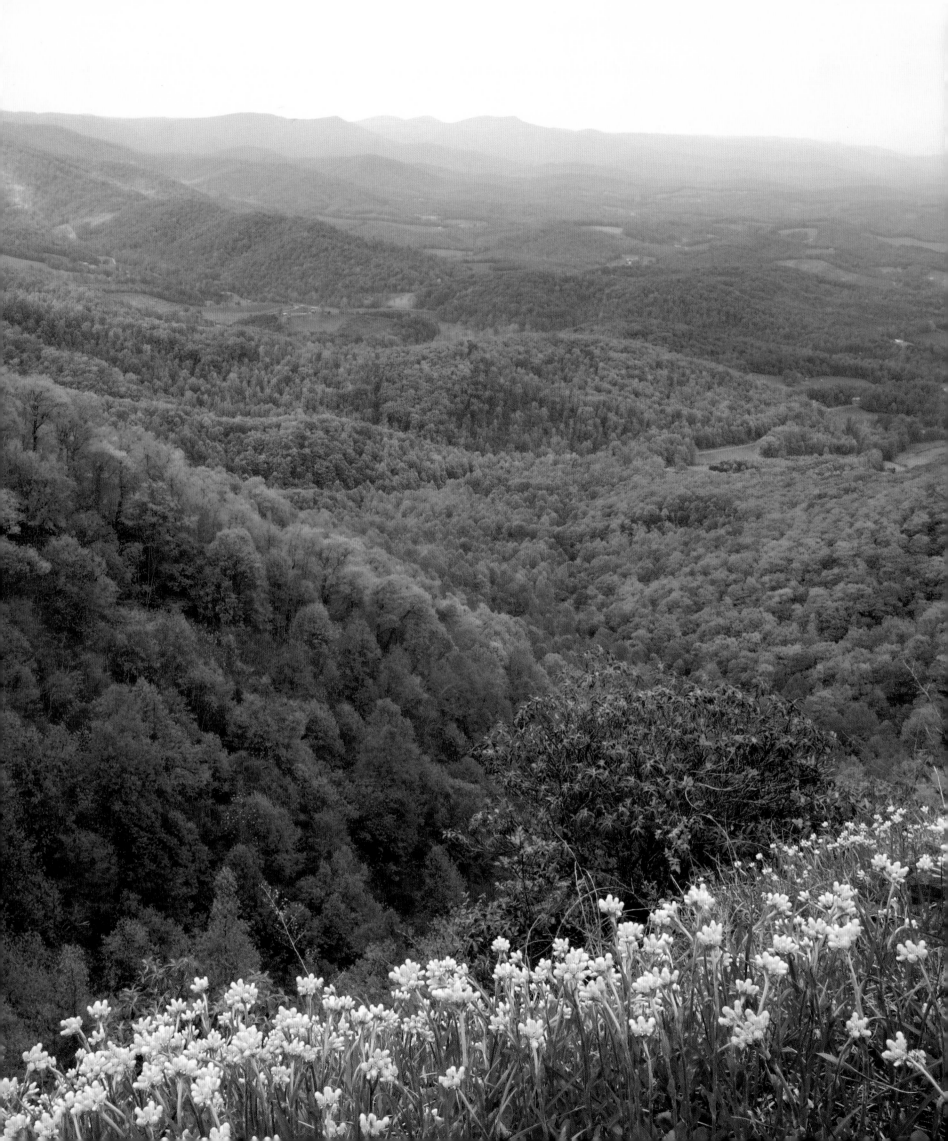

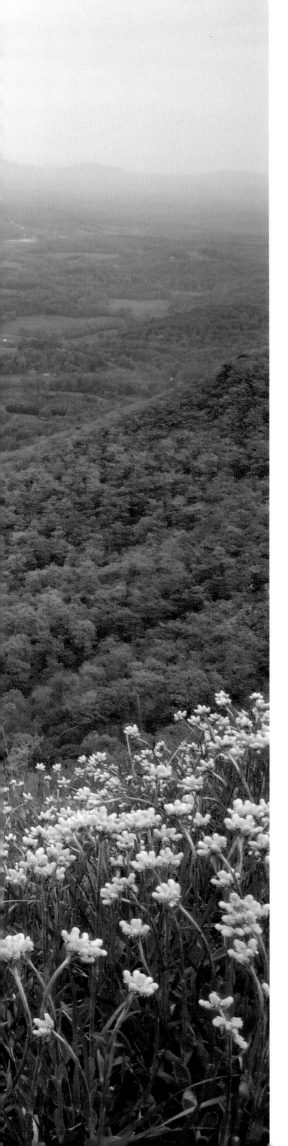

Left: View from Tuggle Gap, elevation 2,752 feet. From the Blue Ridge Parkway, Virginia Highway 8 winds down the mountain to the small town of Floyd, Virginia, which has a thriving arts community and music scene.

Below, top: Bloodroot is one of the first wildflowers to bloom along the parkway—in mid-March at lower elevations (Rock Castle Gorge, the James River) but not until April at higher spots (Boone Fork Trail).

Below, bottom: Yellowstone Falls, in North Carolina's Graveyard Fields, is so named for the yellow lichens and minerals found on rocks there. It falls a total of 125 feet into two pools.

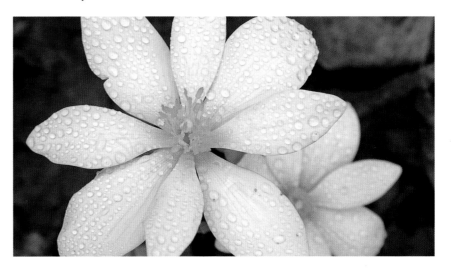

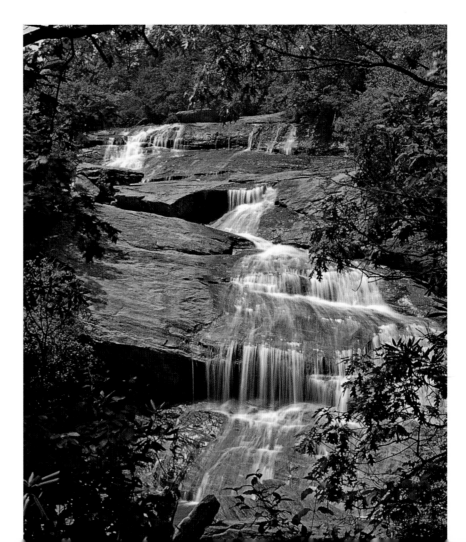

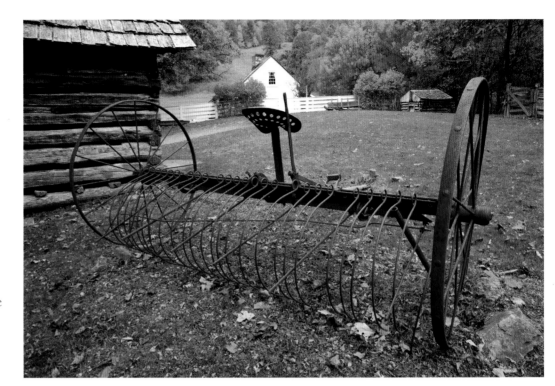

Right: A 2.1-mile loop trail leads to the Johnson Farm at Peaks of Otter. This was a working farm from 1854 to the mid-1940s and has been restored to the 1930s era. Today it's the site of living history demonstrations.

Facing page: Smart View, at milepost 154.5, was one of the five original recreation areas on the parkway. Its more than 500 acres opened to the public in 1940.

Below: Present-day farmers harvest cabbage near Mabry Mill in Virginia.

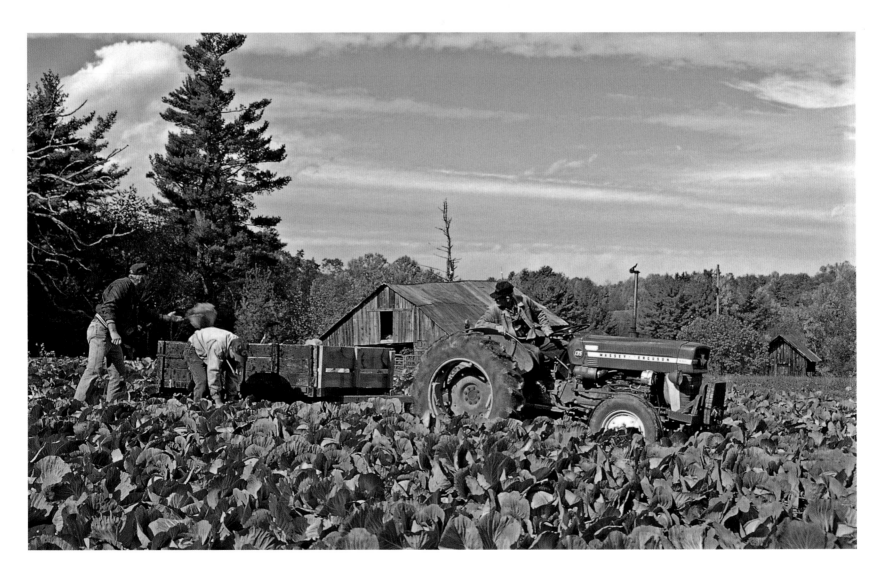

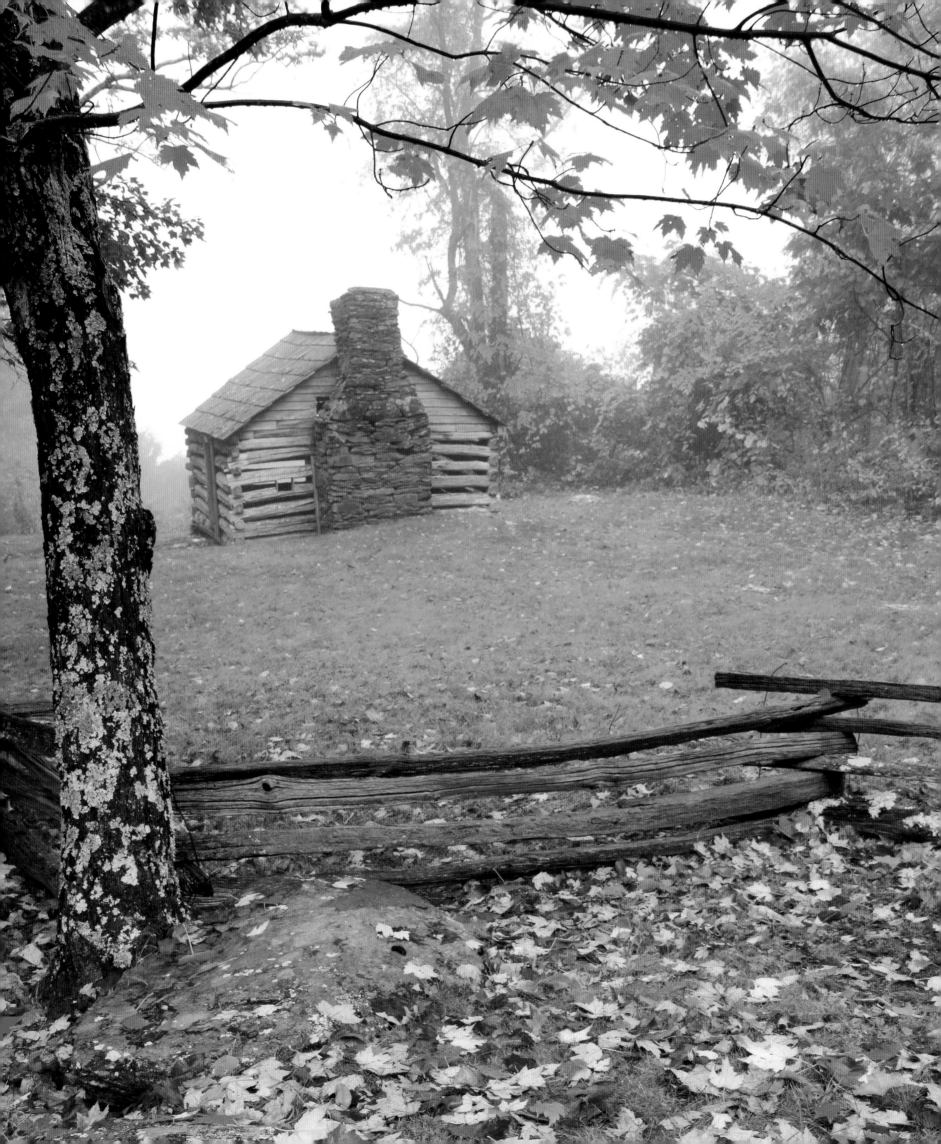

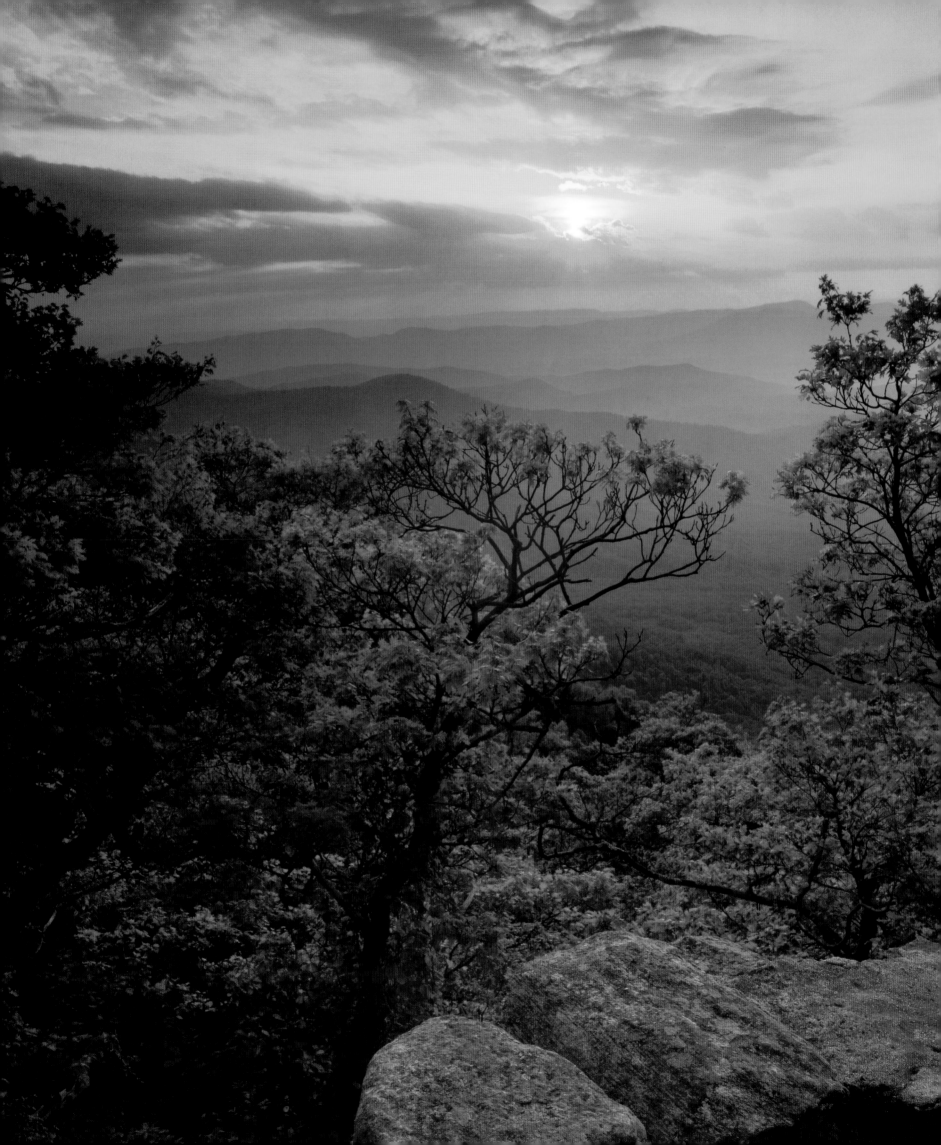

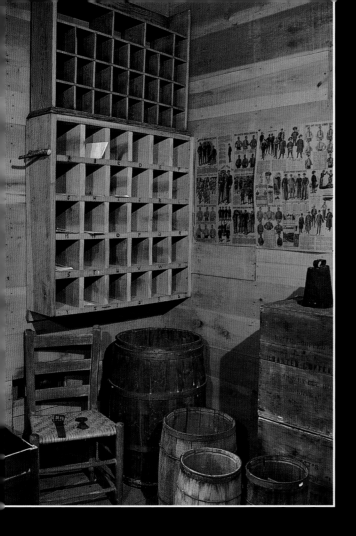

Left: In the nineteenth century, George Vanderbilt hired foresters Gifford Pinchot and Carl A. Schenck to manage the trees on his Biltmore Estate. Part of the Vanderbilt land became the core of the Pisgah National Forest. Today, the 6,500-acre Cradle of Forestry historic site commemorates those historic beginnings. Pictured are mailboxes in the old commissary.

Facing page: A tranquil sunset, seen from Thunder Ridge. The Appalachian Trail passes through Thunder Ridge Wilderness Area.

Below: The Garden Creek Church, built in 1897, sits along the east prong of Roaring River in Stone Mountain State Park.

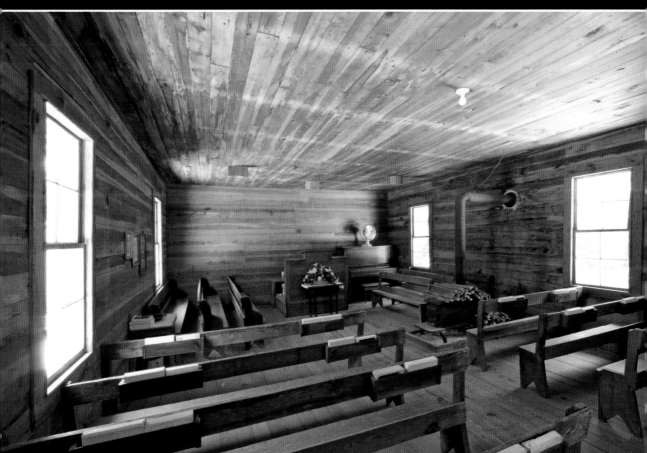

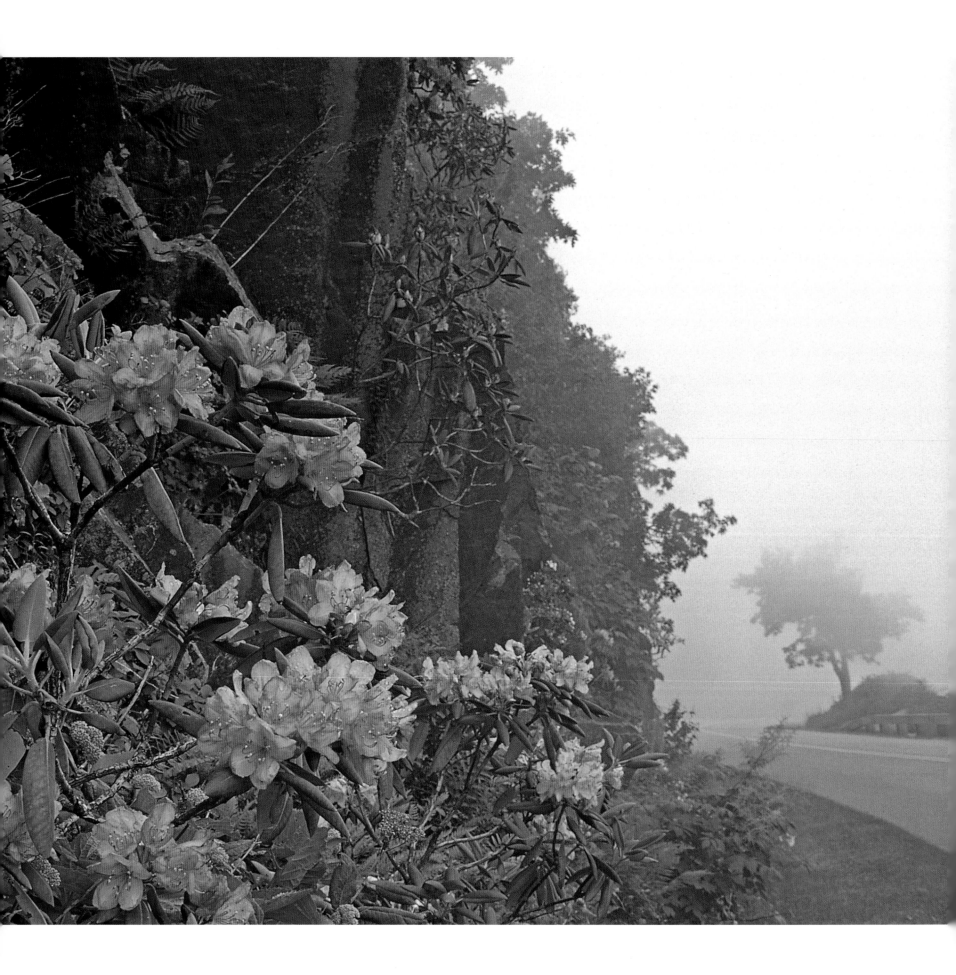

Right: The slender petals of the fire pink can be seen along roadsides from April through September.

Left: The Blue Ridge Parkway winds around Virginia's Apple Orchard Mountain, adorned in pink rhododendrons.

Below: Mist makes ghosts of the rhododendron at Fallingwater Cascades, Peaks of Otter. The Flat Top and Fallingwater Cascades trails each were named a National Recreation Trail in 1982.

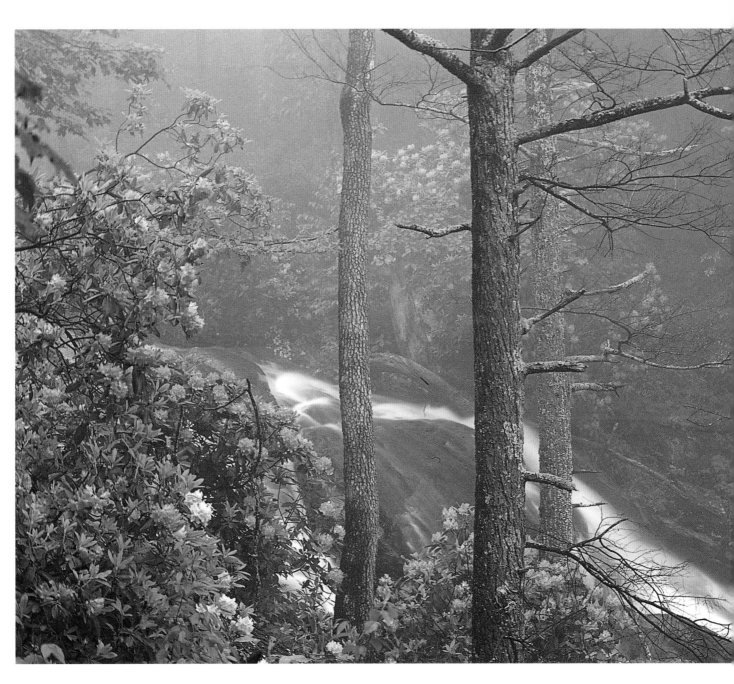

Above: Orange jewelweed, also called spotted touch-me-not, catches the morning dew at Black Balsam.

Right: Flame azalea blooms in 5,497-foot-high Craggy Gardens Recreation Area. Craggy Gardens' heath balds were part of the national forest until the Forest Service ceded 700 acres to the Blue Ridge Parkway.

Facing page: Autumn leaves catch on rocks in North Carolina's Linville River.

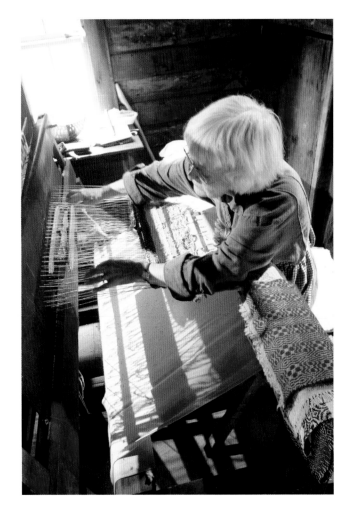

Above: An artist demonstrates weaving at the historic Mabry Mill in Virginia. Loom weaving was brought to the Appalachian region by European settlers and was later refined during Appalachia's arts and crafts revival in the second half of the nineteenth century and the early twentieth century.

Right: Sunrise sends shadows across the parkway at Whetstone Ridge, near milepost 29.

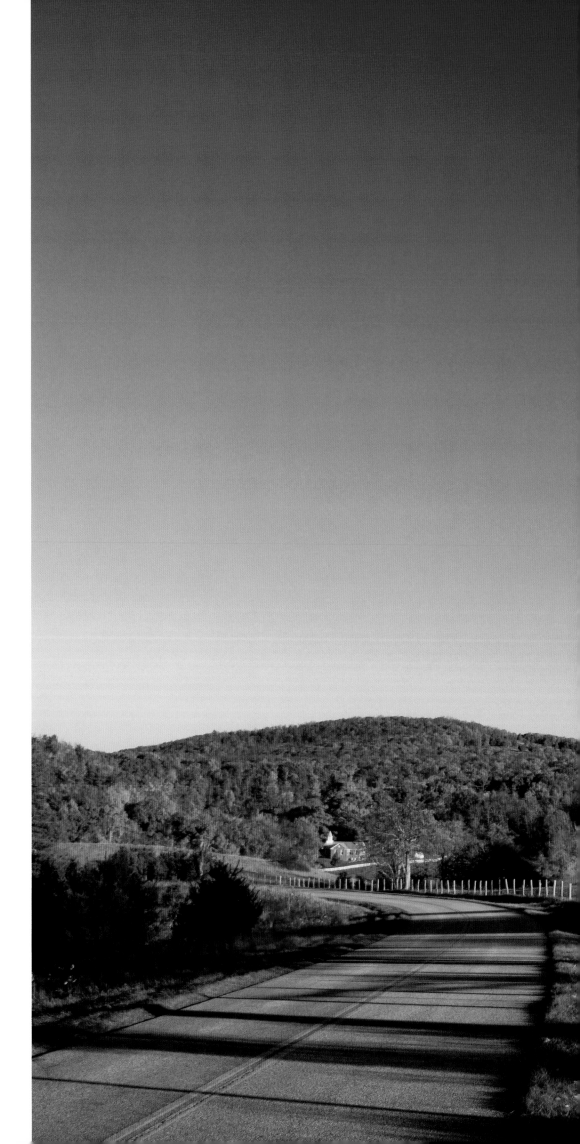

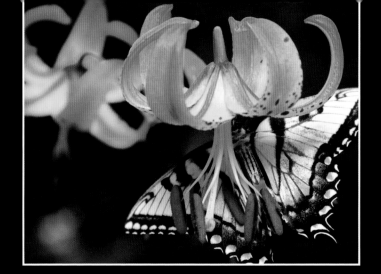

Right: A swallowtail butterfly alights on a Turk's cap lily. The flower blooms from June through August.

Facing page: Canada geese swim in Bass Lake at Moses H. Cone Memorial Park in North Carolina.

Below: Tuggle Gap, in Virginia, remains farmland, though the parkway-adjacent farms have changed over the years. Row crops (potatoes, pumpkins, squash, cabbage), once a staple in the region, are nearly gone; most agricultural land along the parkway is now hayfields or pasture

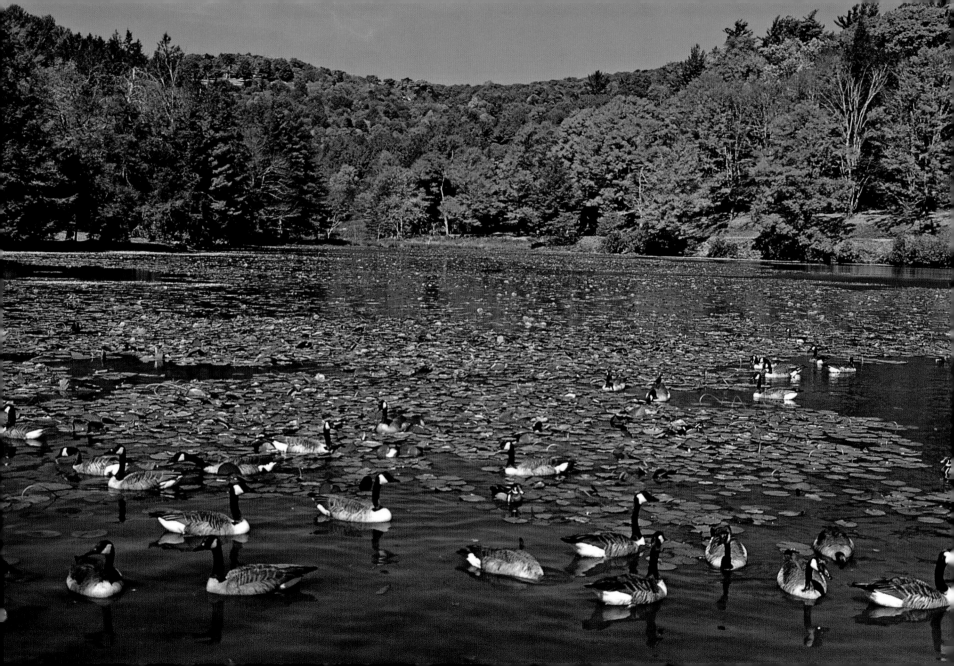

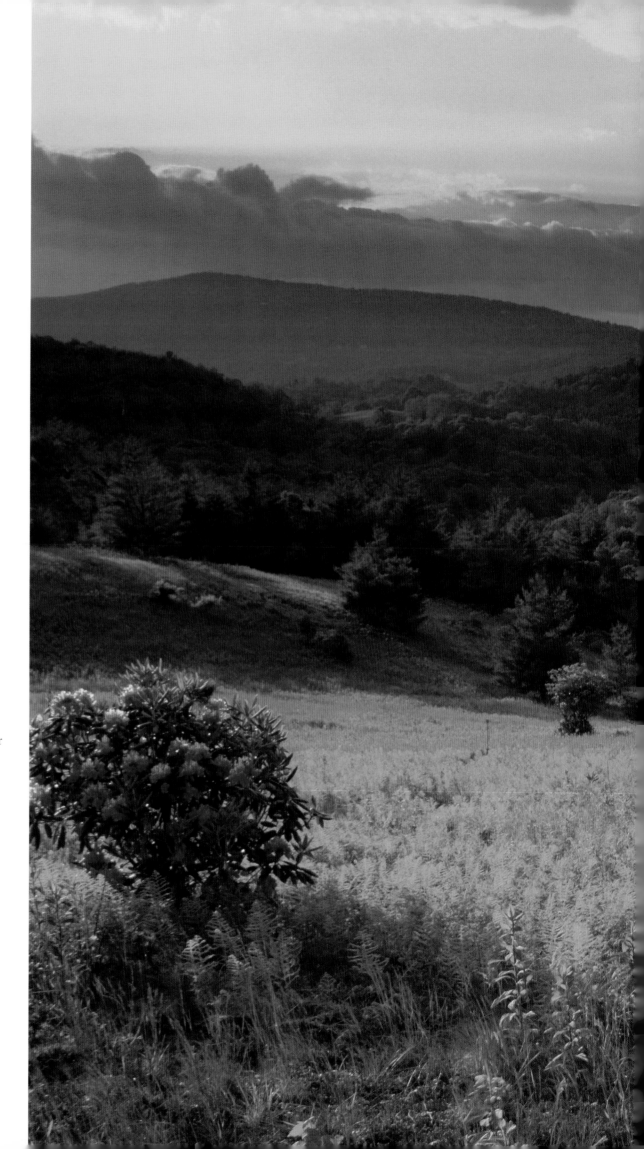

Sunset stains the sky a soft rose at Thunder
Hill, near Blowing Rock, North Carolina.
The Thunder Hill parking lot overlook, at
elevation 3,776 feet, is at milepost 290.5.

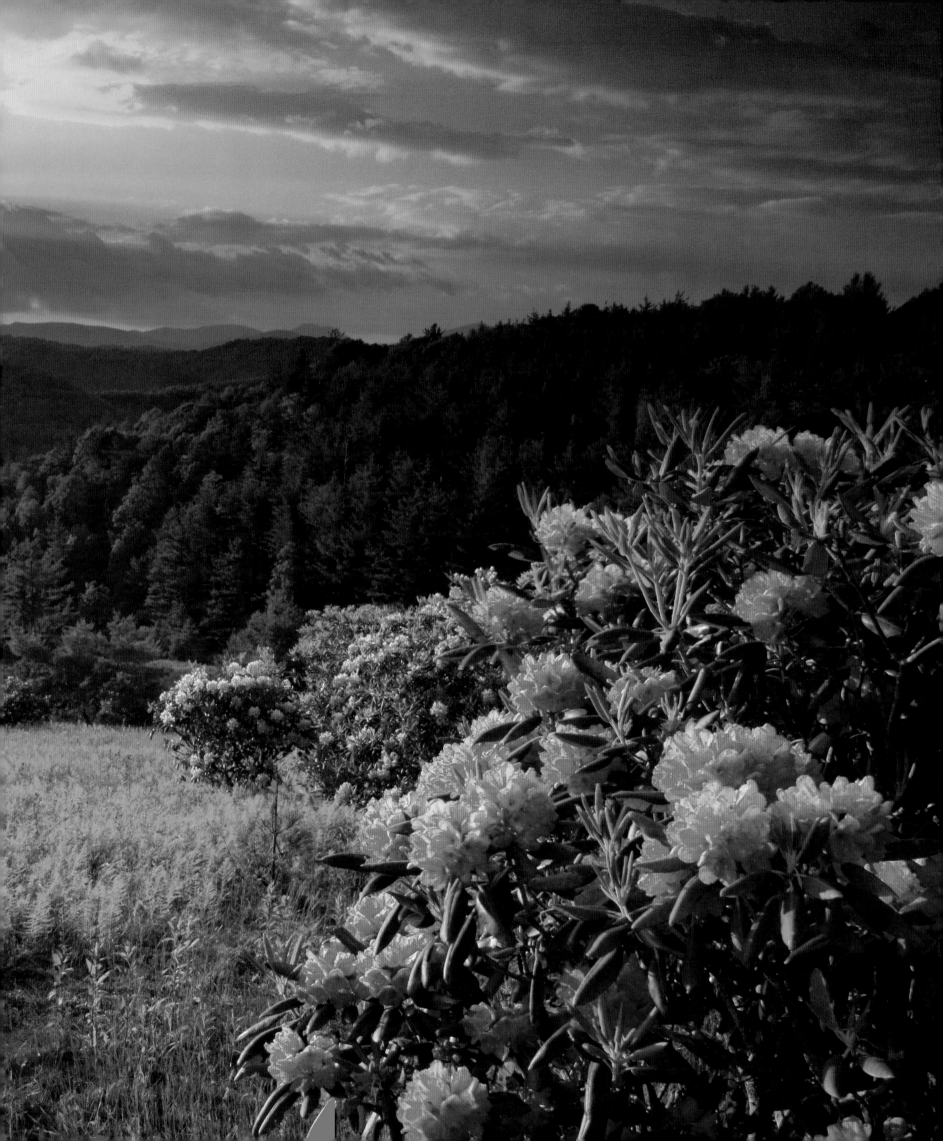

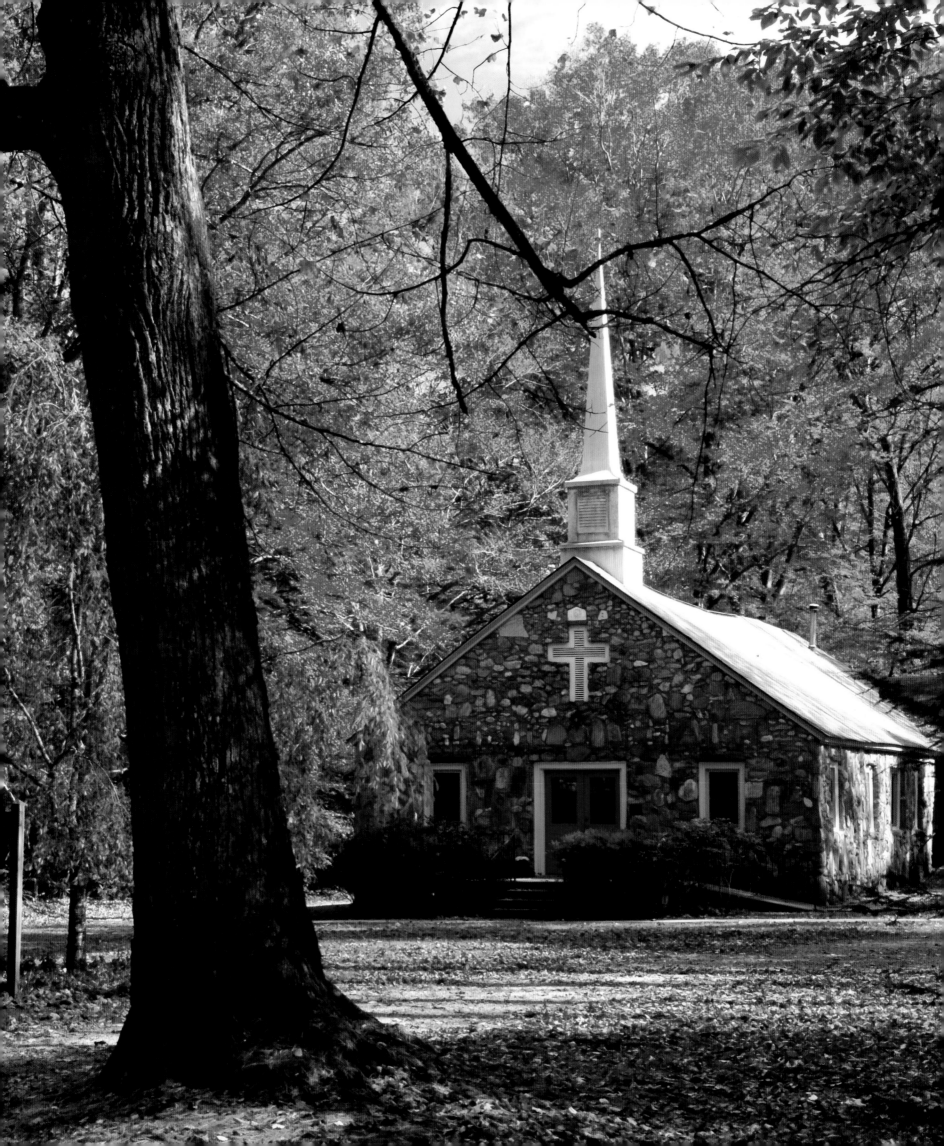

Above: The nectar produced by butterfly weed attracts its namesake in summer. Other plants beloved by butterflies include common milkweed, Joe Pye weed, ironweed, and boneset.

Left: Winter cold freezes the cascades of Crabtree Falls in Virginia (not to be confused with Crabtree Falls in North Carolina). The falls can be reached by a detour off the parkway at the Tye River Gap down Virginia Highway 56.

Facing page: The original English Chapel was founded in 1860 by circuit rider A. F. English in Transylvania County, North Carolina. In 1940, the church was rebuilt using stone from the Davison River, along which it sits.

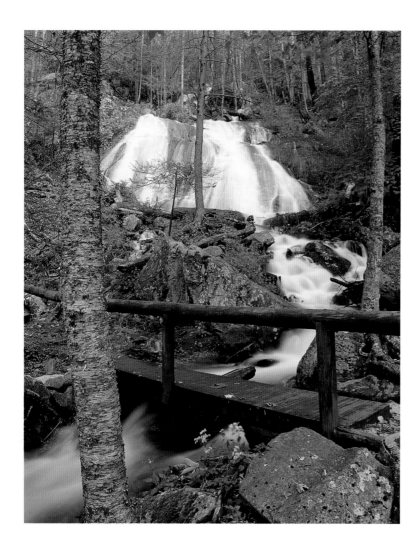

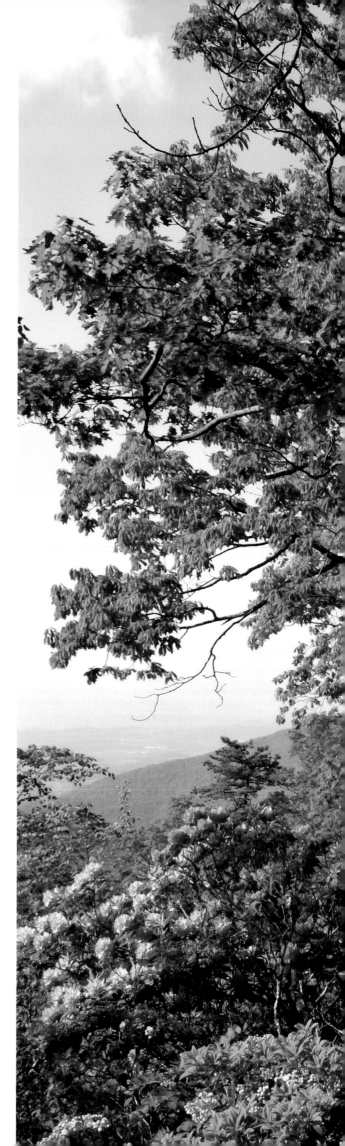

Above, top: The Yankee Horse Overlook Trail in Virginia is a short, easy hike to thirty-foot Wigwam Falls and follows part of what was once a narrow-gauge railroad bed.

Above, bottom: A moth seems to seek out its echo on mountain laurel blossoms.

Right: The parkway passes near Buena Vista, Virginia, in May.

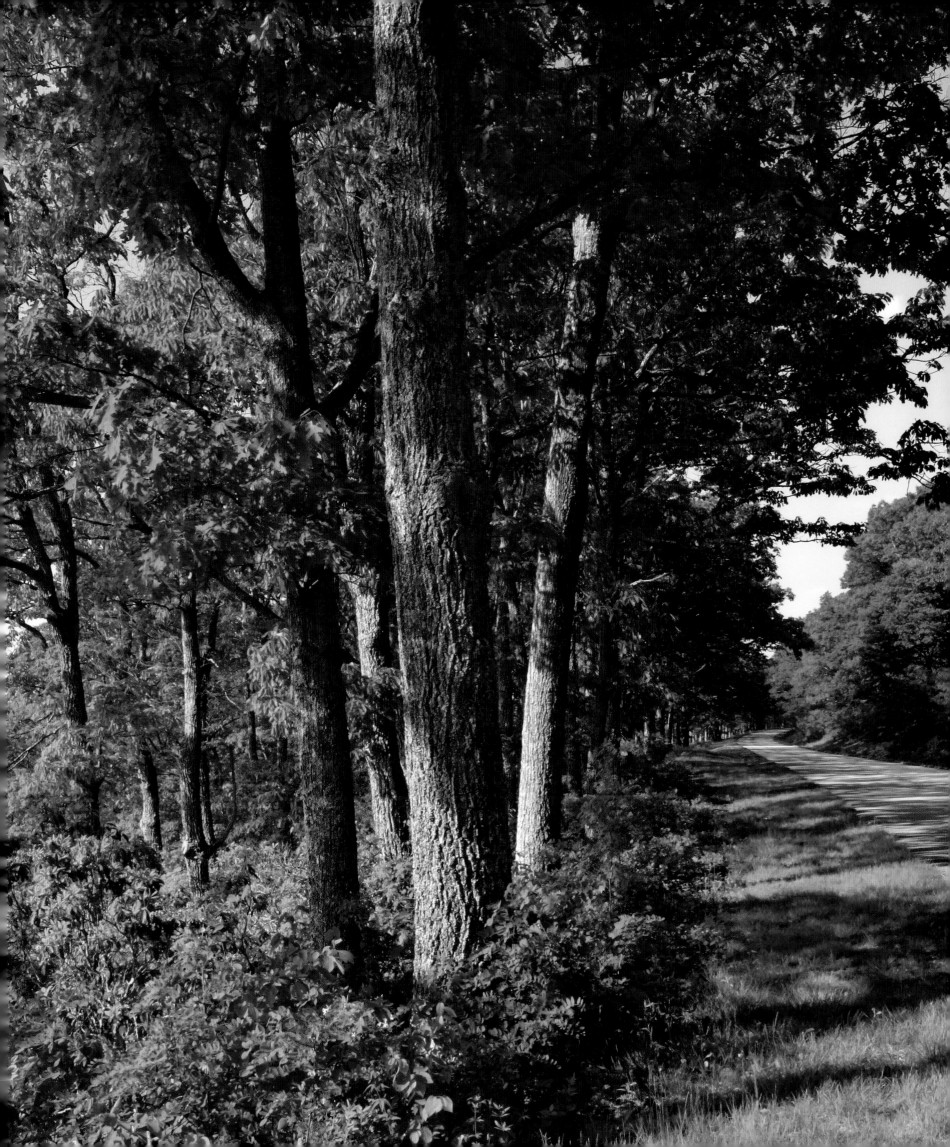

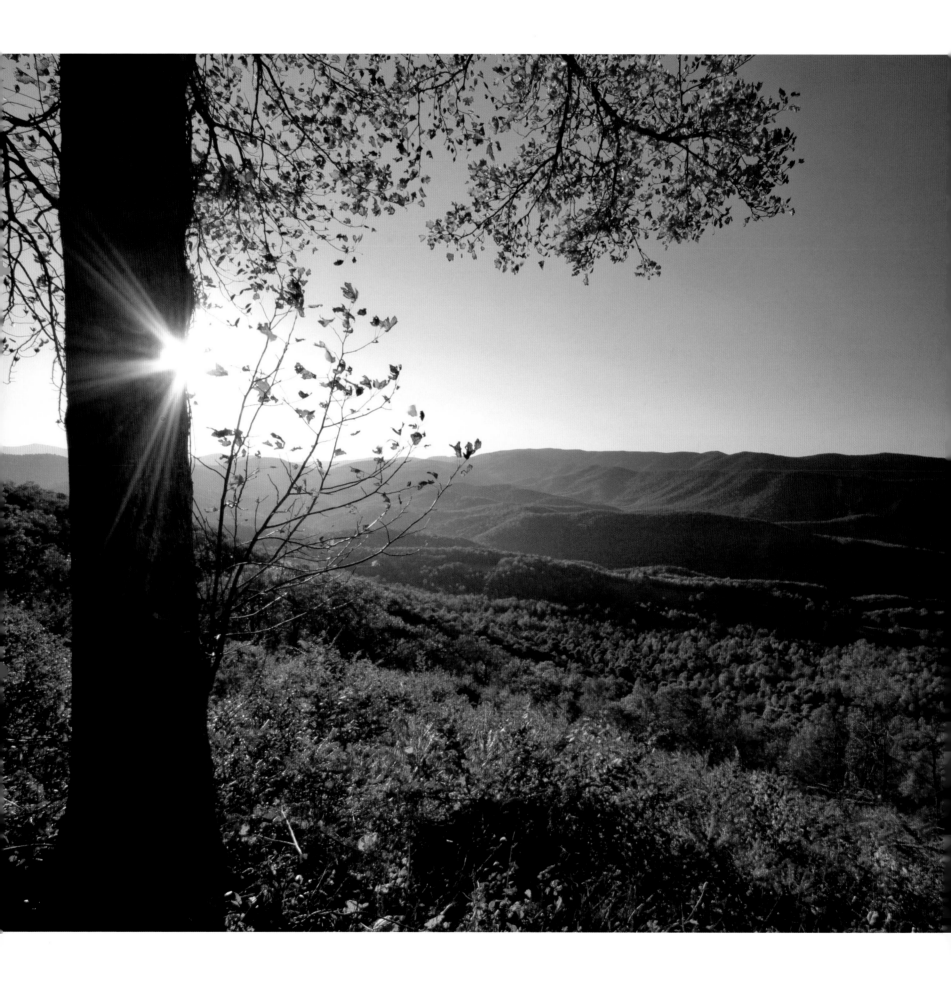

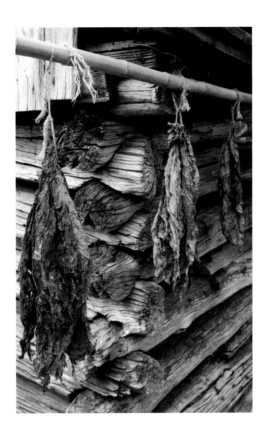

Left: Tobacco dries against log walls at the Johnson Farm, Peaks of Otter.

Far left: The sun sets in the Ravens Roost area of the parkway (the overlook is at milepost 10.7 in Virginia).

Below: The Linville River, which has its headwaters on North Carolina's Grandfather Mountain, flows through Linville Gorge to the Catawba Valley, descending 2,000 feet in elevation.

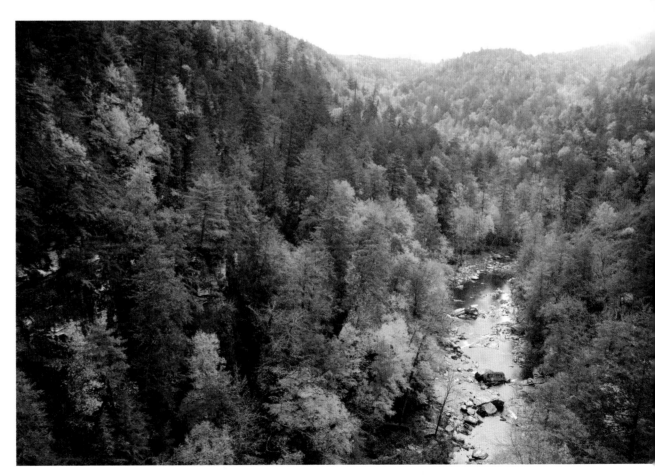

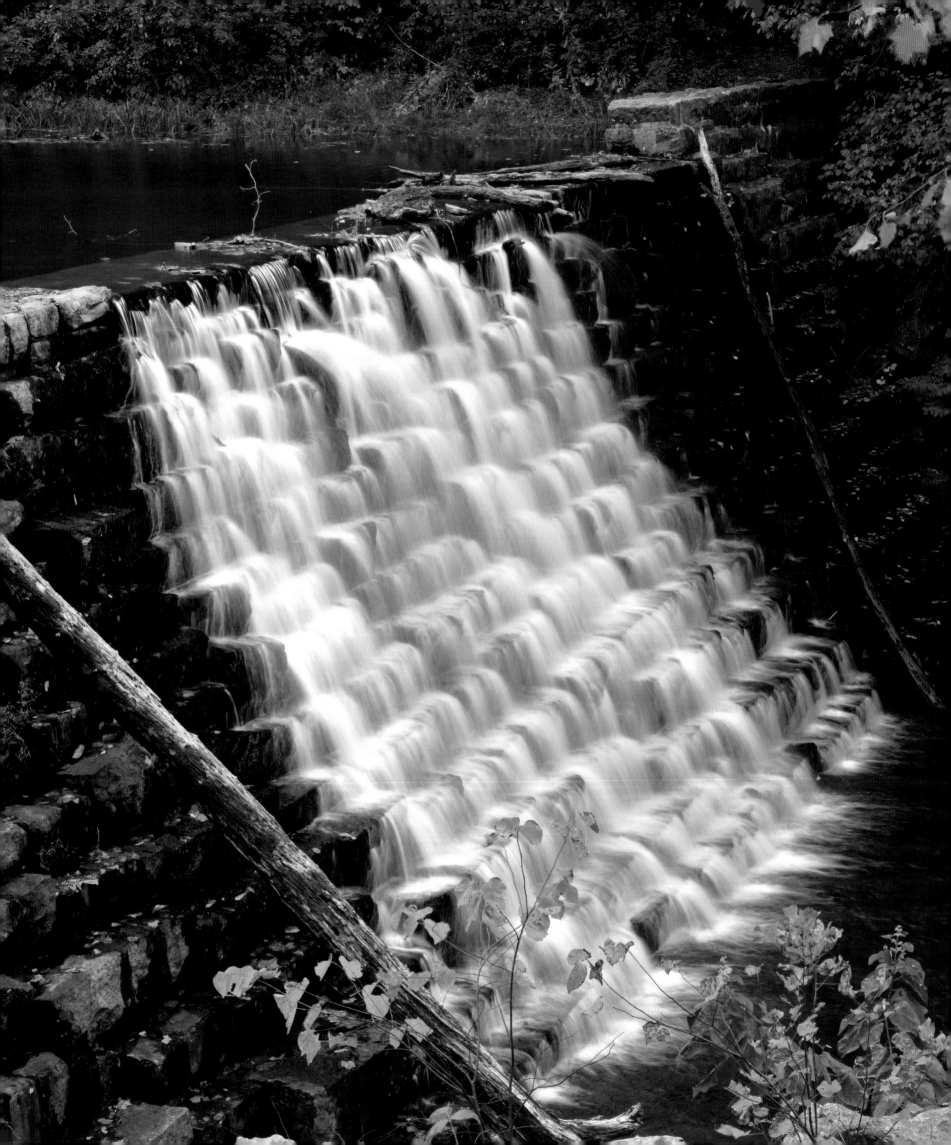

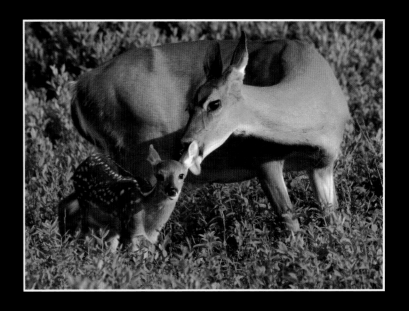

Right: A doe takes care of her fawn. Deer are often most visible in the early morning and in the evening, when they feed.

Facing page: Otter Lake Dam, at milepost 63.1, can be found in the Otter Creek area, which features camping, hiking trails, a restaurant, and a gift shop.

Below: Fog blankets the Shenandoah Valley at the northern end of the parkway, in this view from Ravens Roost.

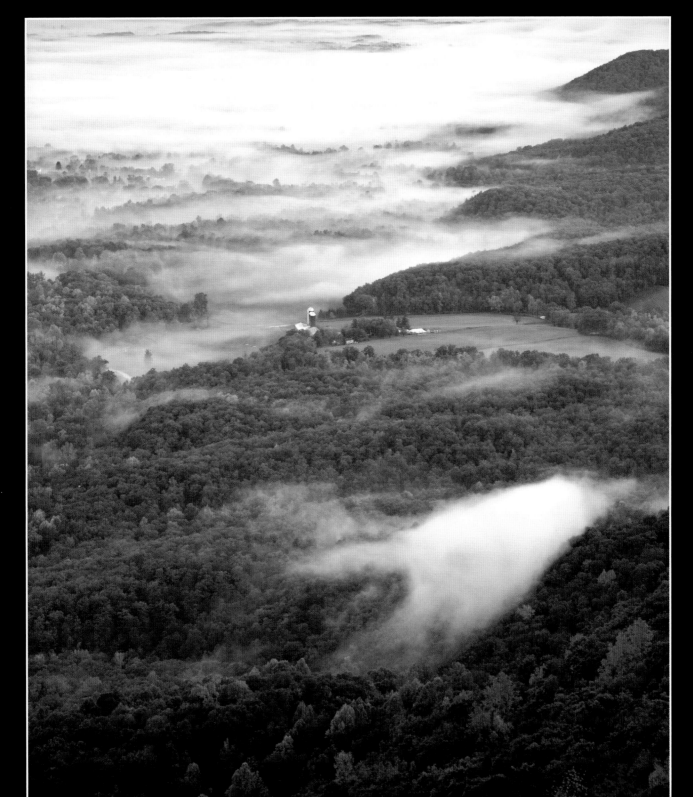

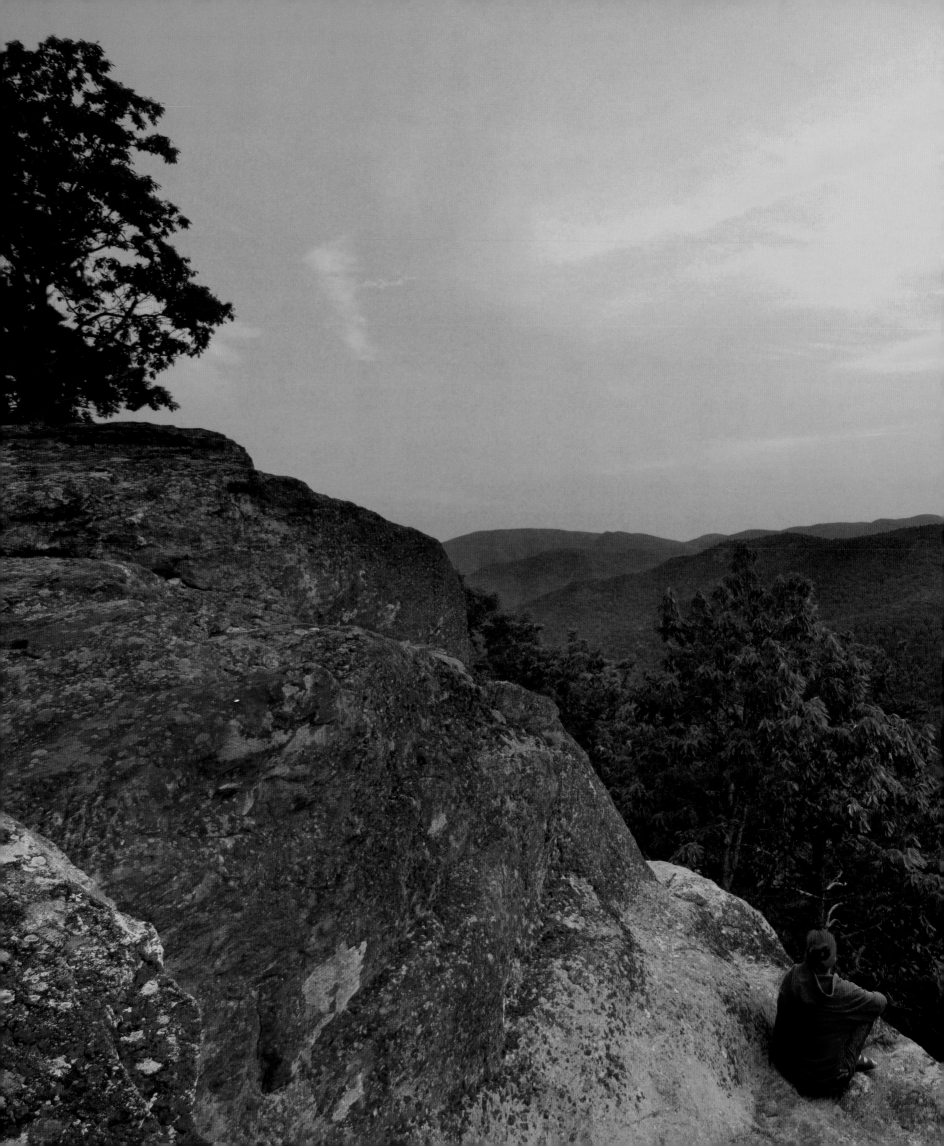

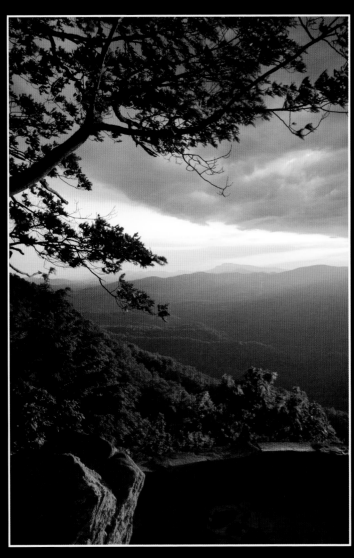

Above: From an elevation of 4,090 feet, Chestoa View, at milepost 320.8, offers vistas of several landmarks, including Grandfather Mountain, Linville Gorge, Hawksbill, and Table Rock. Here, the sun rises, casting a glow across the valley and Grandfather Mountain beyond.

Left: In June and July, area residents can estimate the sunset: twenty minutes after light hits the rock face just under the overlook at Twenty-Minute Cliff, at milepost 19. Note the sliver of moon at the upper right.

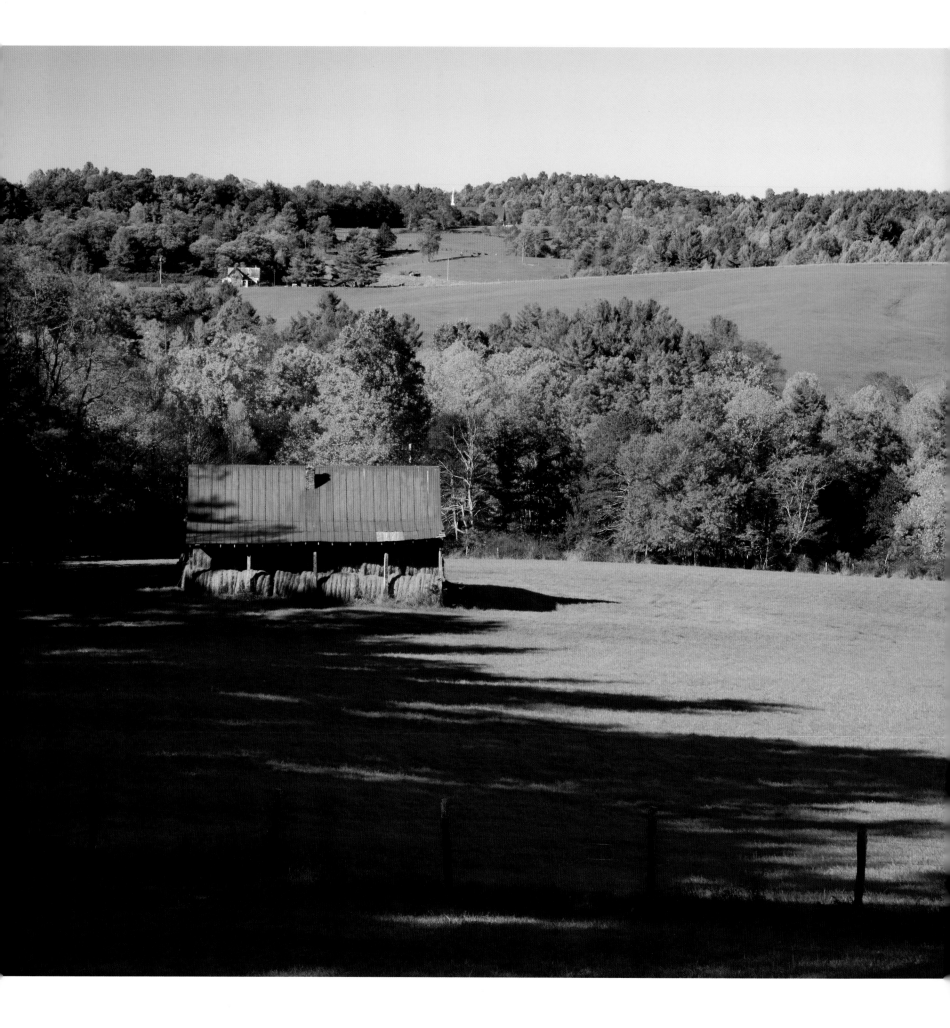

Left: A scarecrow takes a break from chopping firewood at Peaks of Otter's Johnson Farm.

Far left: Piper Gap, at milepost 206.1, was named for civil engineer Col. James H. Piper. In the mid-1800s, he located a site for a new and much-needed road through the gap to connect the county seats of Mount Airy, North Carolina, and Independence, Virginia.

Below: Looking north into Maggie Valley, North Carolina, from U.S. Highway 19, north of the parkway.

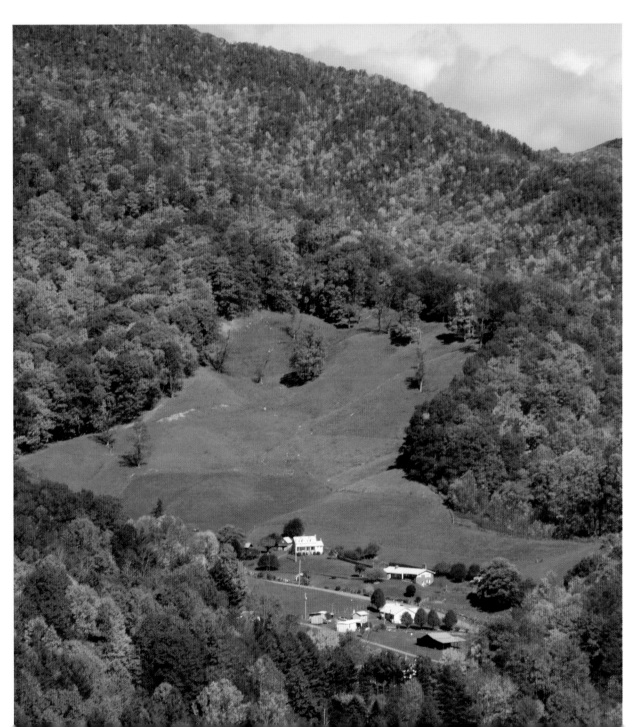

The Blue Ridge Parkway traces a path through Doughton Park in October. The largest recreation area on the North Carolina end of the parkway, Doughton encompasses 5,410 acres and features thirty miles of trails.

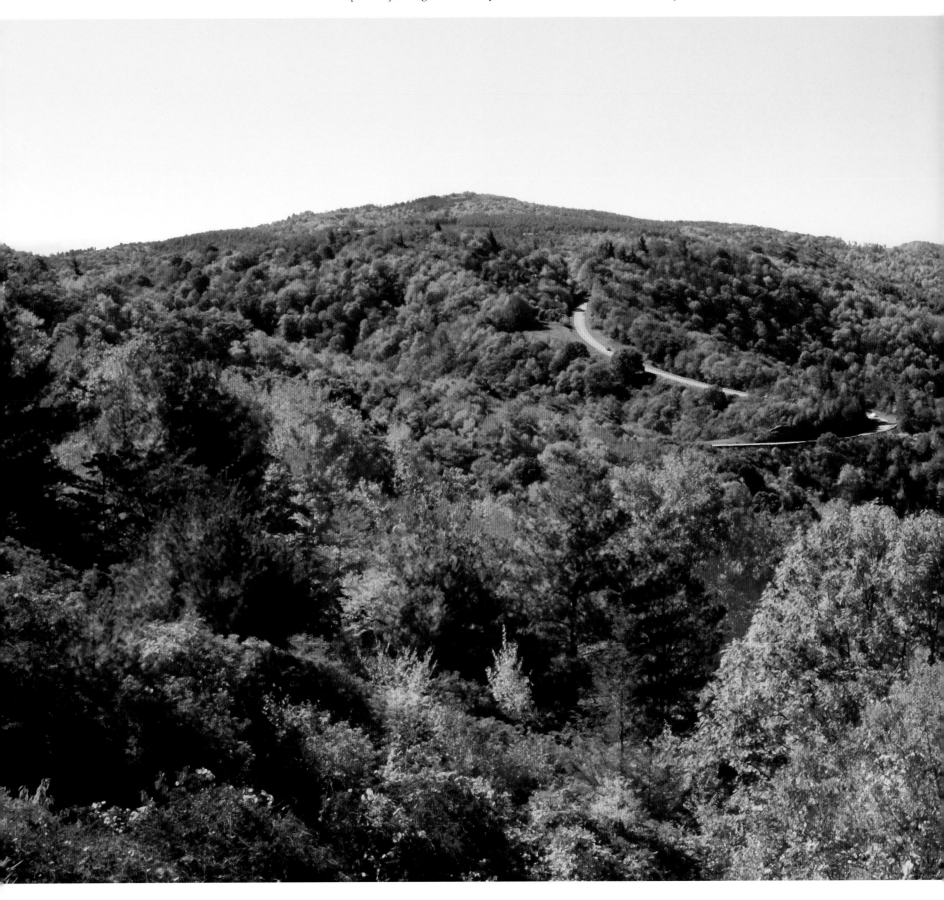

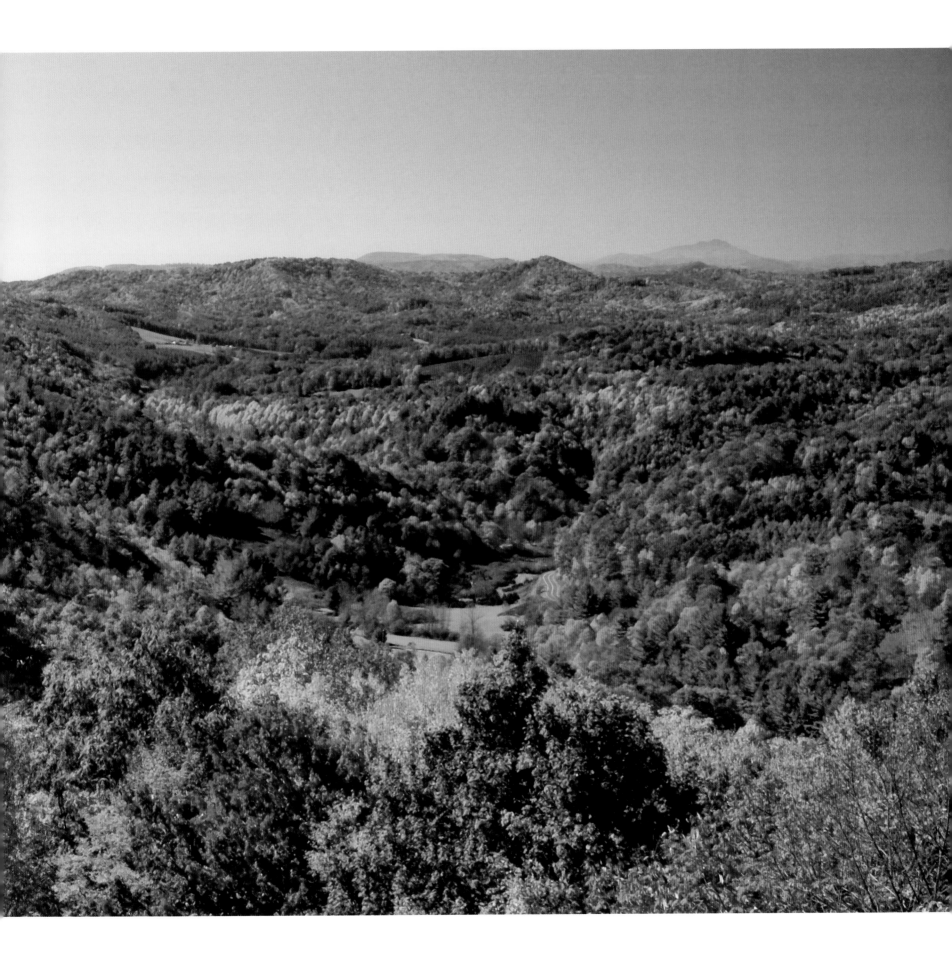

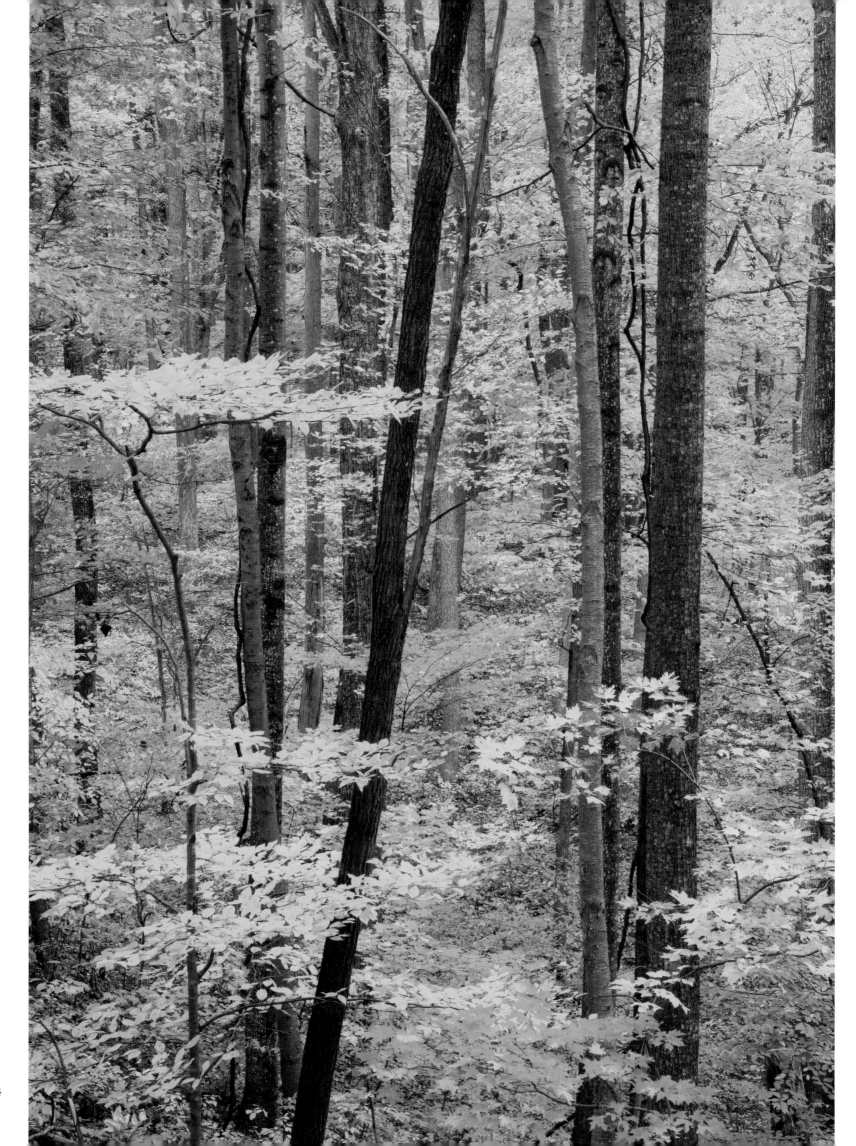

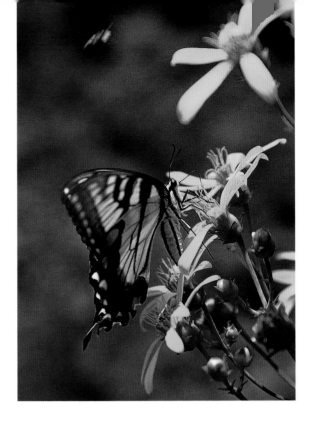

Left: A swallowtail butterfly drinks from a sunflower as a bee waits its turn above.

Facing page: Autumn trees trace verticals near milepost 60.8 in the Otter Creek area of Virginia.

Below: Bicyclists are a blur in the Humpback Rocks area in July. Cycling can be thrilling and challenging on the parkway. In some places, a cyclist may climb as much as 1,100 feet in a little over three miles.

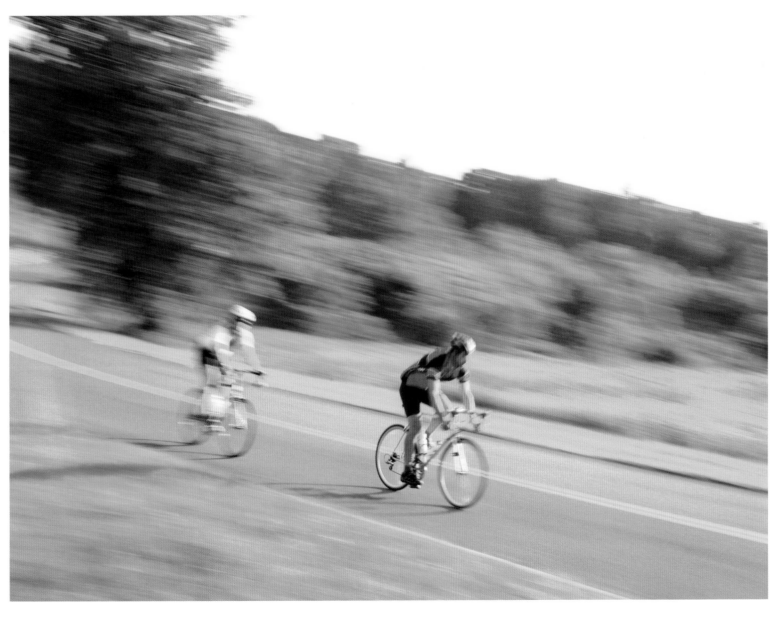

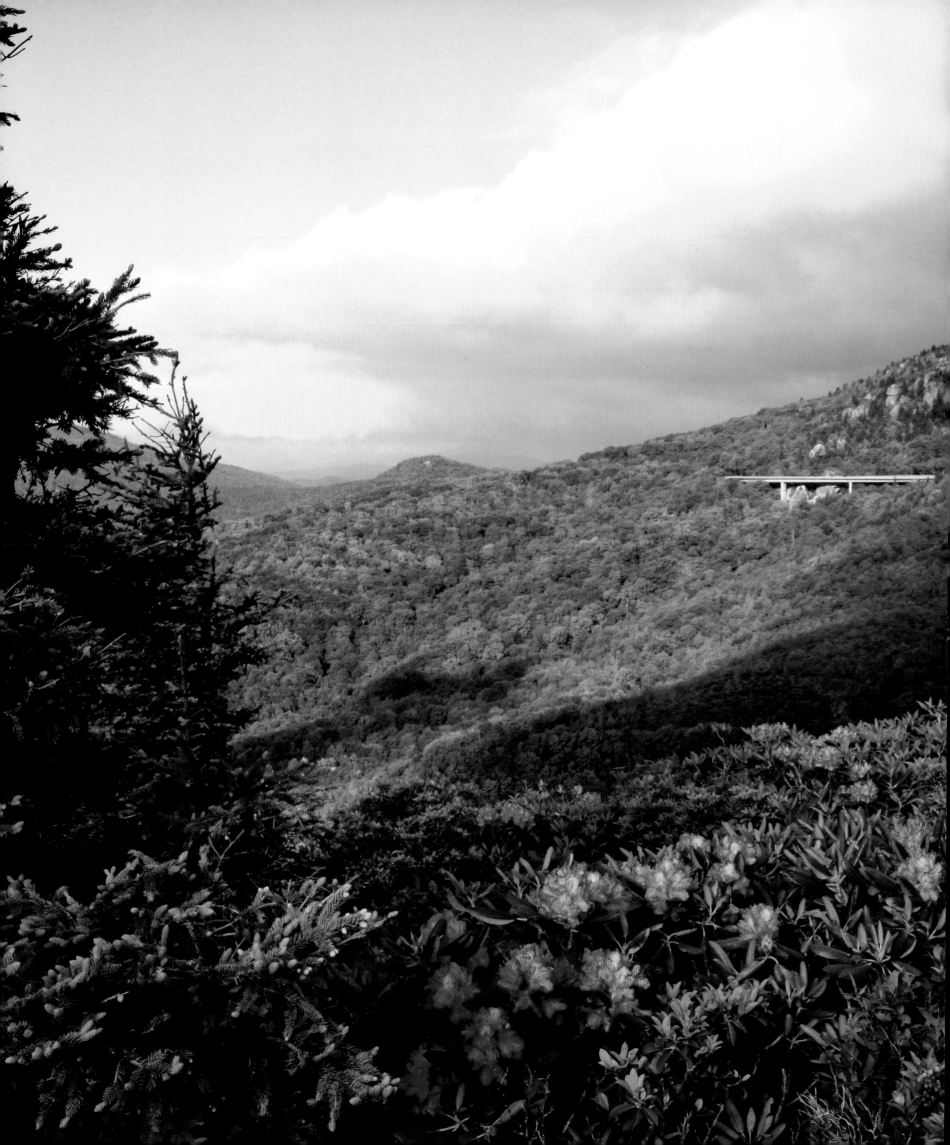

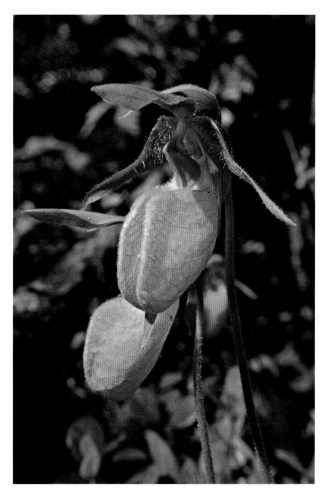

Above: A pink lady's slipper blooms in June. The flower is in the orchid family, and its botanical name, *Cypripedium acaule,* refers to the Greek goddess of love, Aphrodite (Venus to the Romans), who was said to have been born in Cyprus. The flower is also called the venus slipper or the moccasin flower.

Left: The Linn Cove Viaduct, seen from Rough Ridge on the Tanawha Trail in North Carolina.

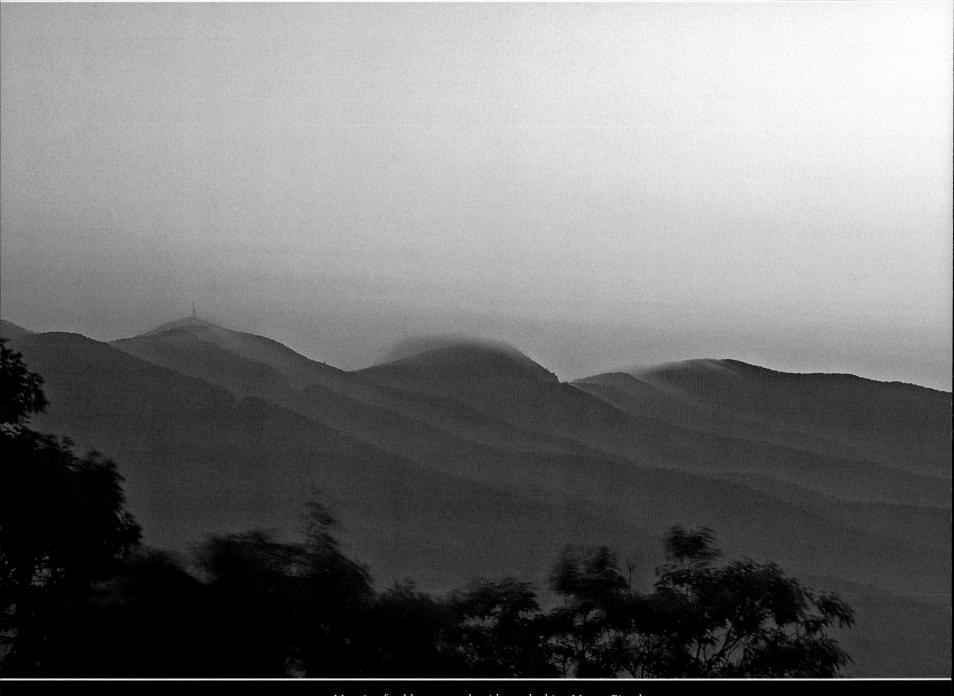

Above: Morning fog blows over the ridges, cloaking Mount Pisgah
(second peak from left, with antenna visible) and Pisgah Lodge.

Facing page: The day ends near U.S. Highway 60 in Virginia.

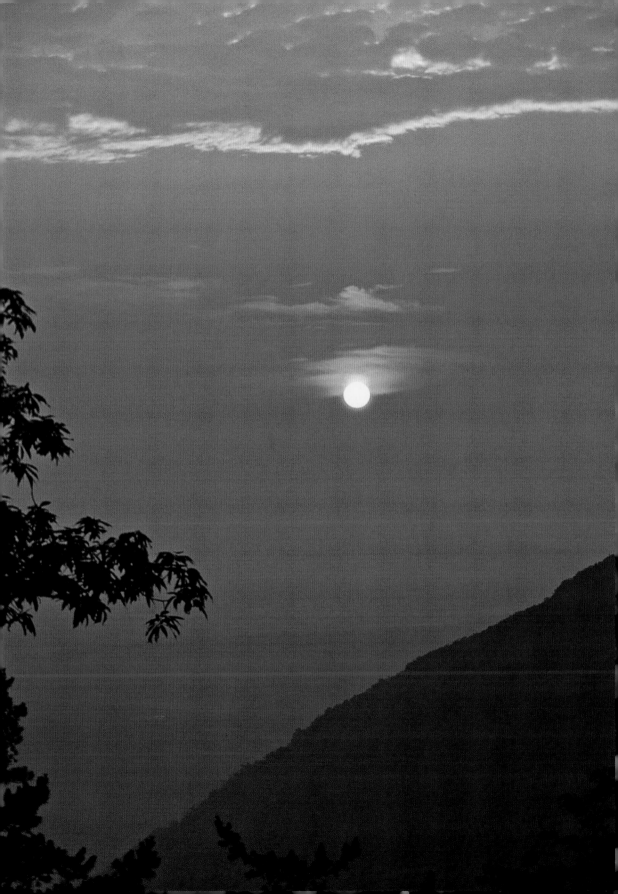

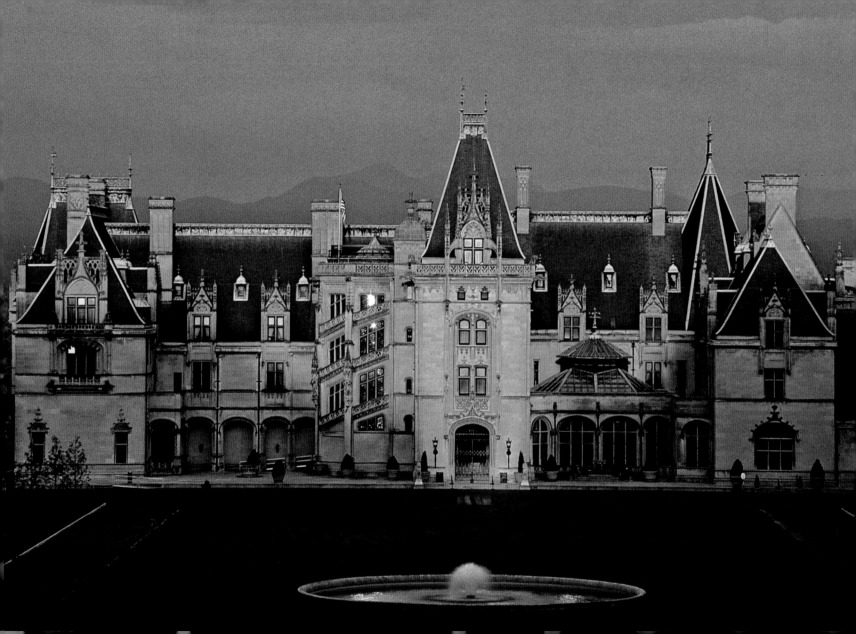

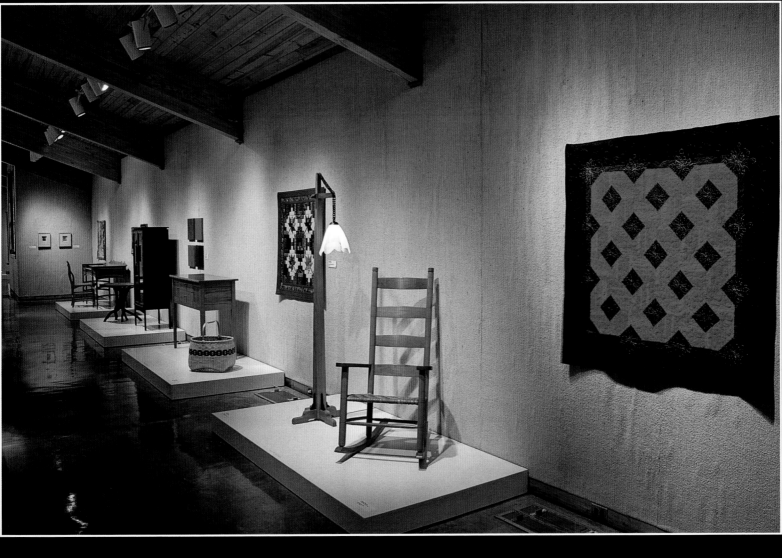

Above: The Folk Art Center, at milepost 382 in Asheville, North Carolina, is operated by the National Park Service and the Southern Highland Craft Guild. One of several guild locations in North Carolina, Kentucky, and Tennessee, this main facility hosts exhibits, demonstrations, and other events celebrating the arts heritage of the region.

Left: A doorway into the past at E. B. Jeffress Park (milepost 271.9) frames a tree tinged with autumn's blush. The cabin dates back to around 1840.

Facing page: The first light of dawn illuminates the stately countenance of Biltmore Estate in Asheville, North Carolina.

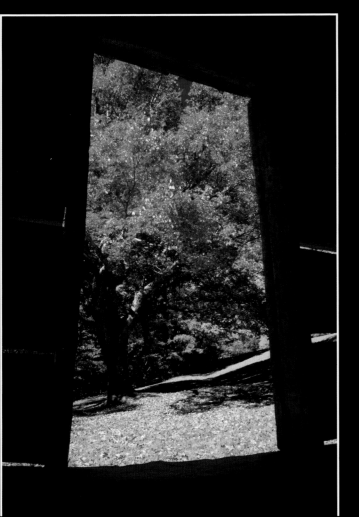

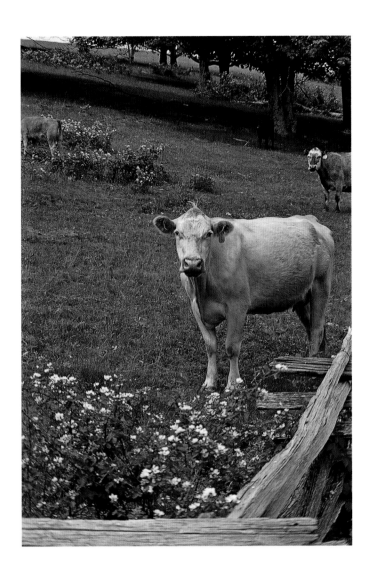

Left: A cow studies the photographer in the Rocky Knob area, mileposts 167 to 174, one of the five original parks on the parkway.

Facing page: Rocky outcroppings and mountain laurel at Doughton Park, mileposts 238.5 to 244.8.

Below: Whetstone Church near Montebello, Virginia.

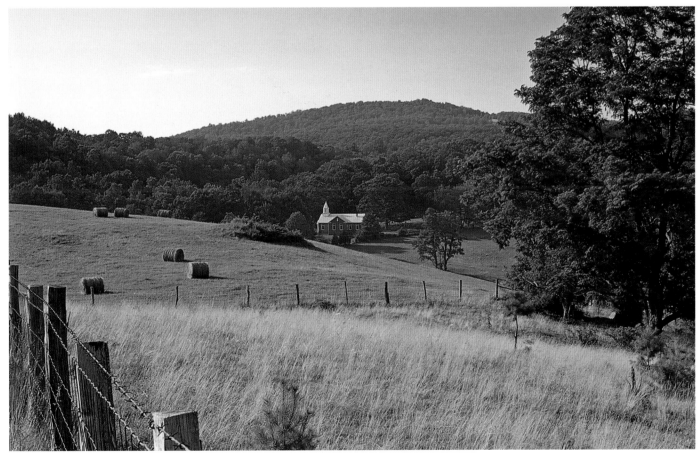

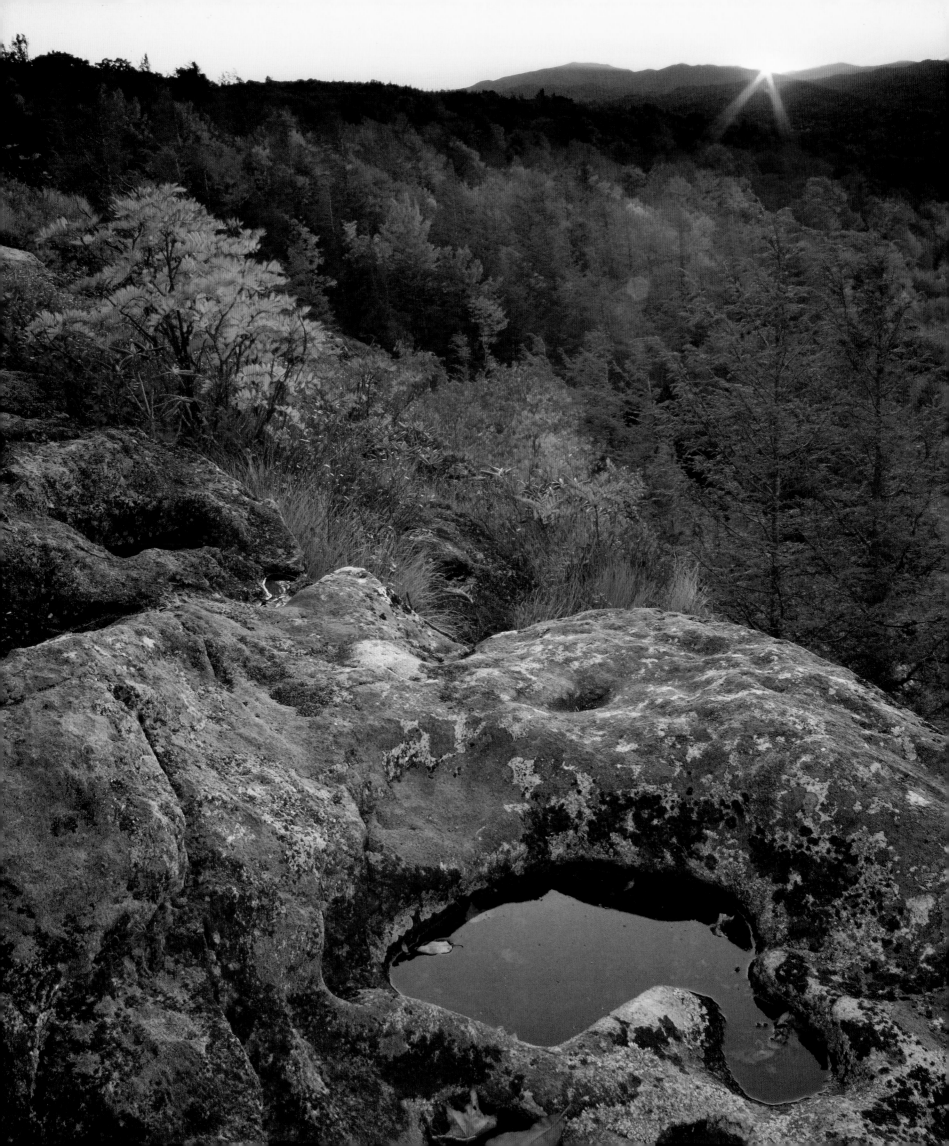

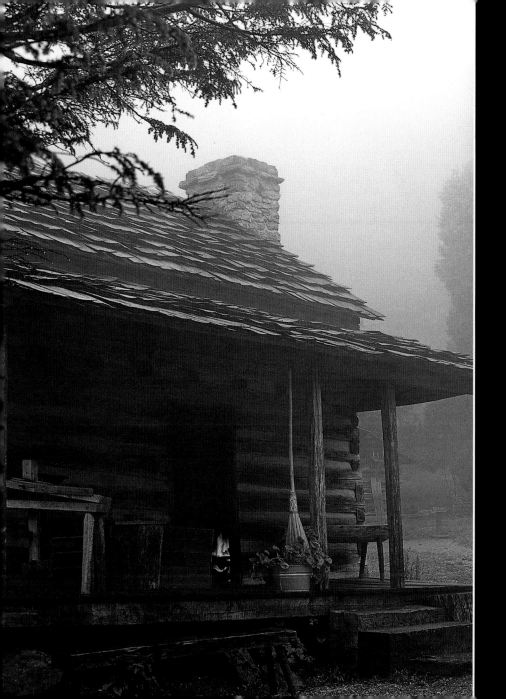

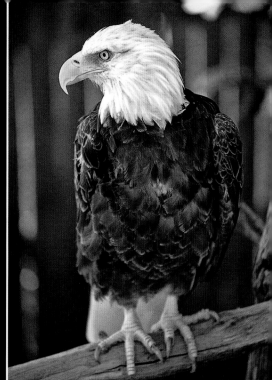

Above: Mill Mountain Zoo in Roanoke, Virginia, is home to species including the bald eagle, cougar, snow leopard, and other creatures, both domestic and exotic.

Left: A warm hearth glows through the fog surrounding the farmstead cabin at Humpback Rocks in Virginia. It's believed the construction style of the traditional mountain log cabin originated with German settlers.

Facing page: Autumn leaves reflect the sun's glow at Flat Rock, at milepost 308.3. In the foreground is a rain-filled "pothole," a favorite feature among visitors to Flat Rock.

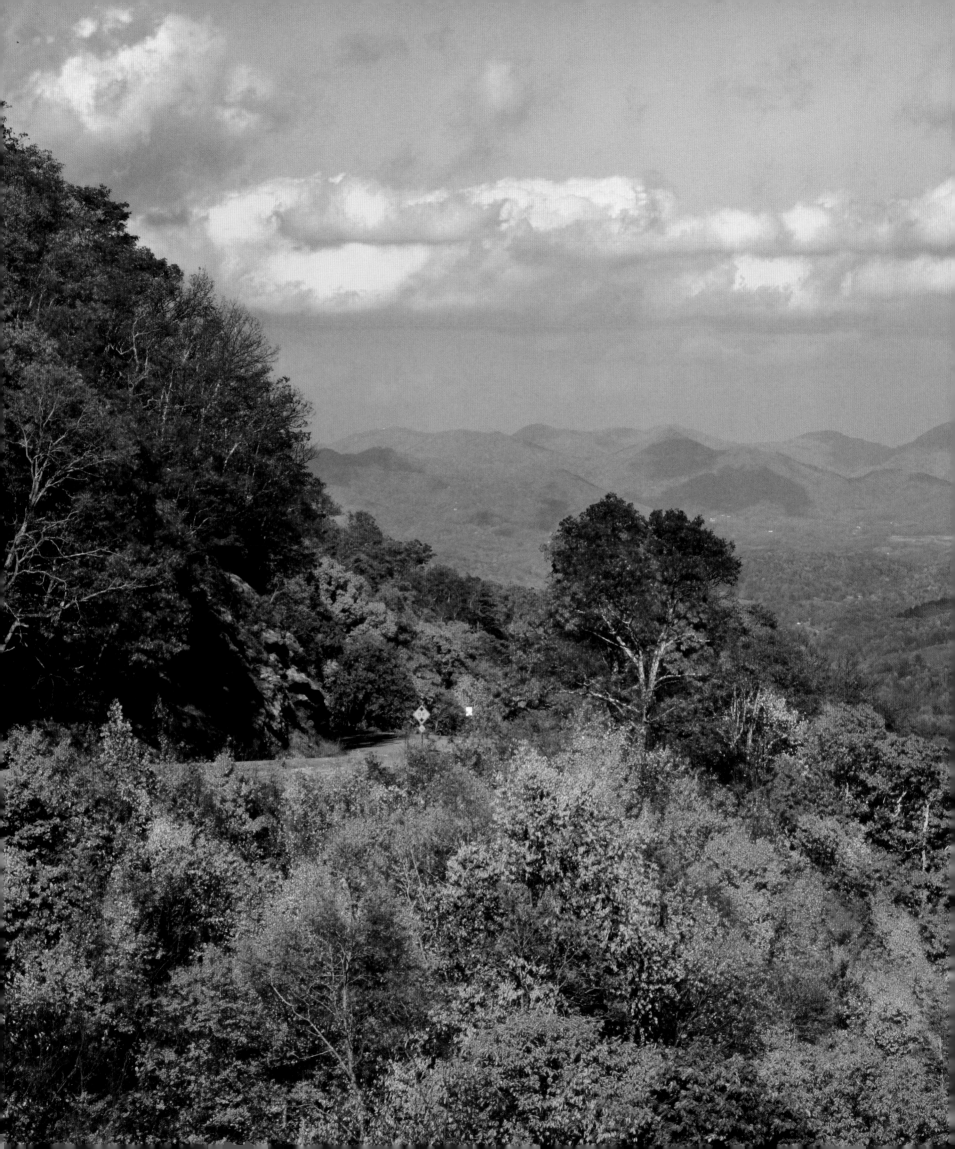

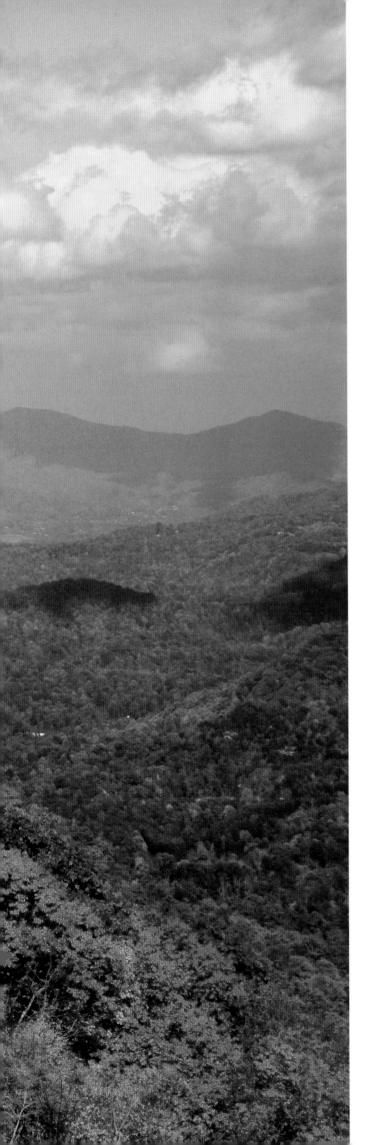

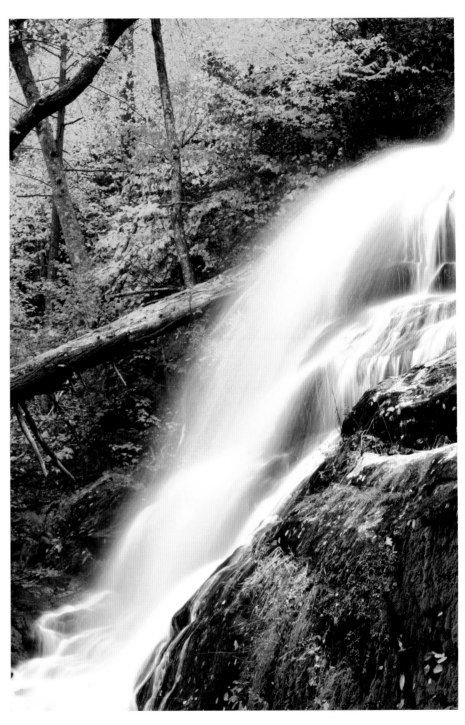

Above: Virginia's Crabtree Falls tumbles a total of 1,200 feet over more than five cascades.

Left: Shadows and light play on the slopes in the area of Sylva, North Carolina, in October.

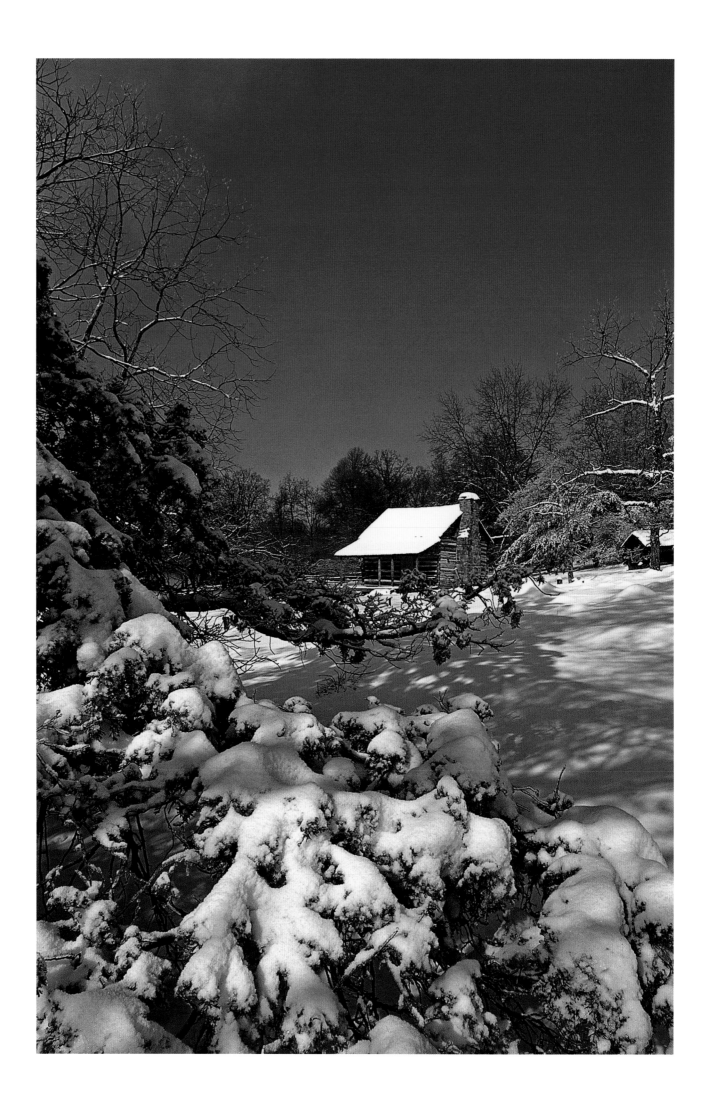

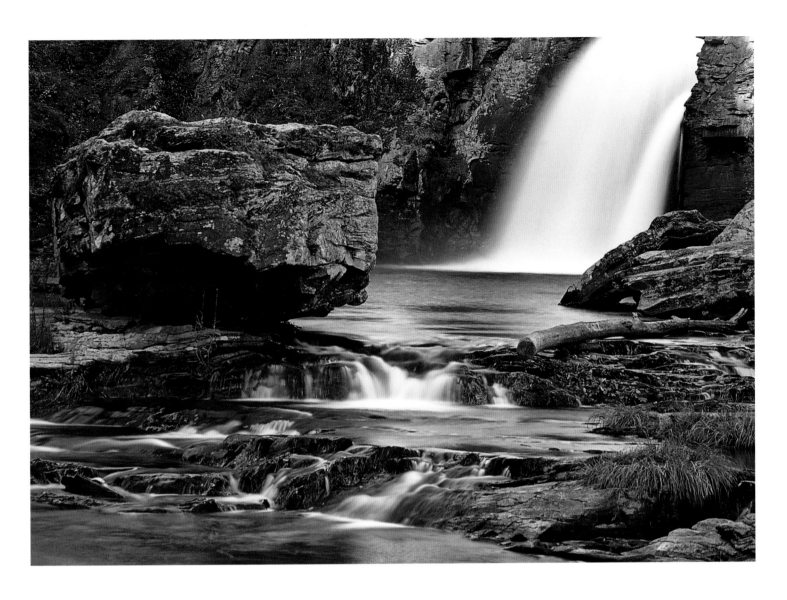

Above: The rush of water at North Carolina's Linville Falls reflects light and rock like liquid silver.

Facing page: Snow blankets the restored cabin at Humpback Rocks.

Left: From May to October, rabbit-foot clover grows along roadsides, its colors ranging from pink to grey.

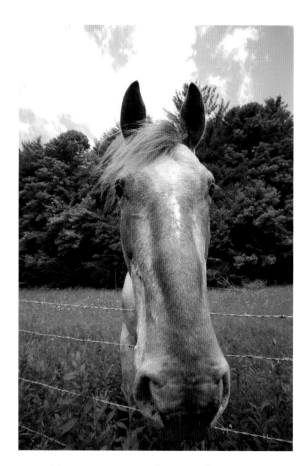

Above: A horse peers over a fence at a farm near Linville, North Carolina.

Right: Appropriately, the Blue Ridge Parkway starts here at Rockfish Gap, once an important mountain pass for trade in the region. Today, the pass serves as the terminus points for both the parkway and Skyline Drive; a railroad tunnel, Interstate 64, and U.S. Highway 250 all wend their way here.

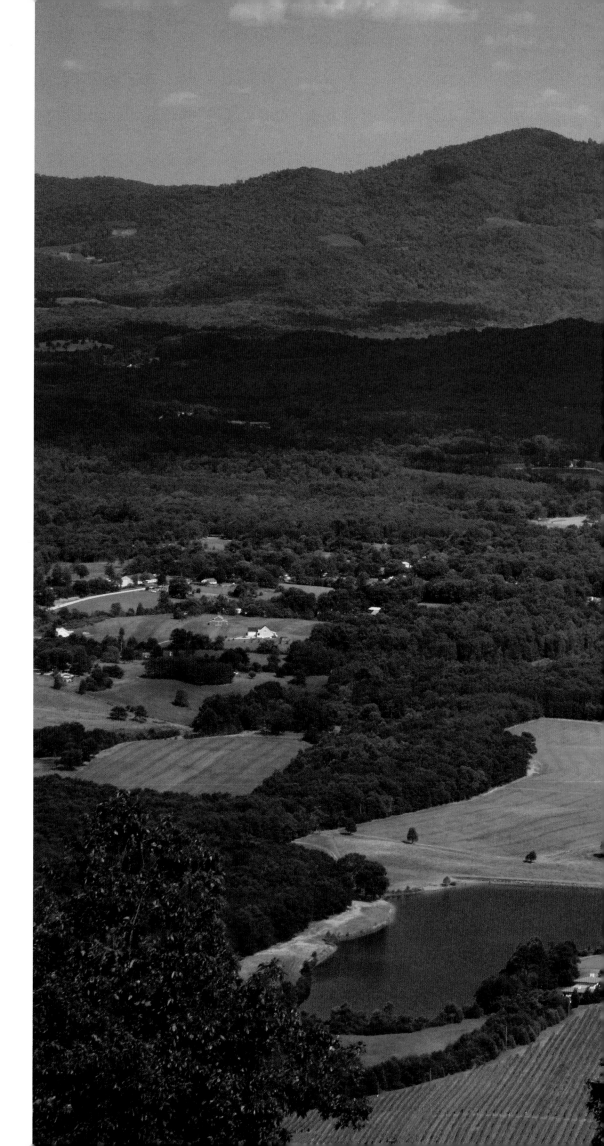

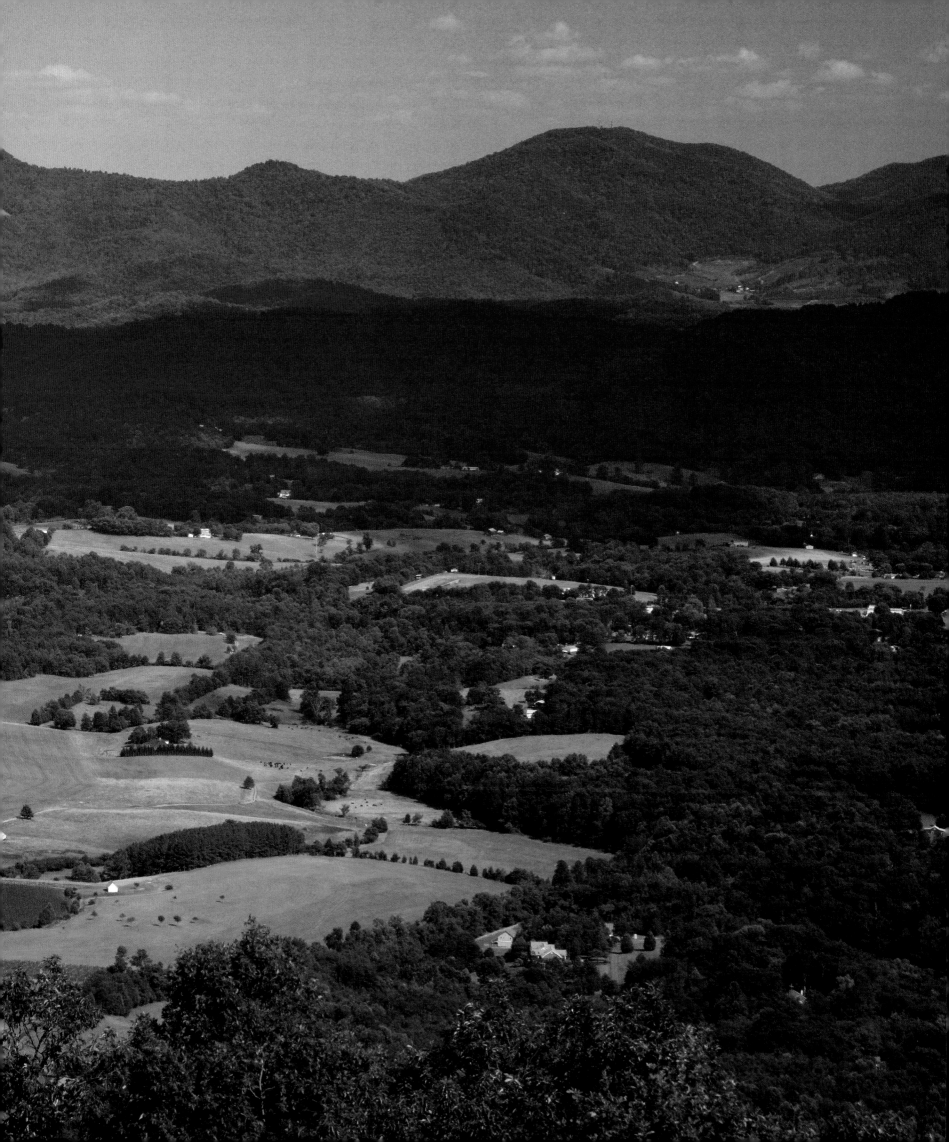

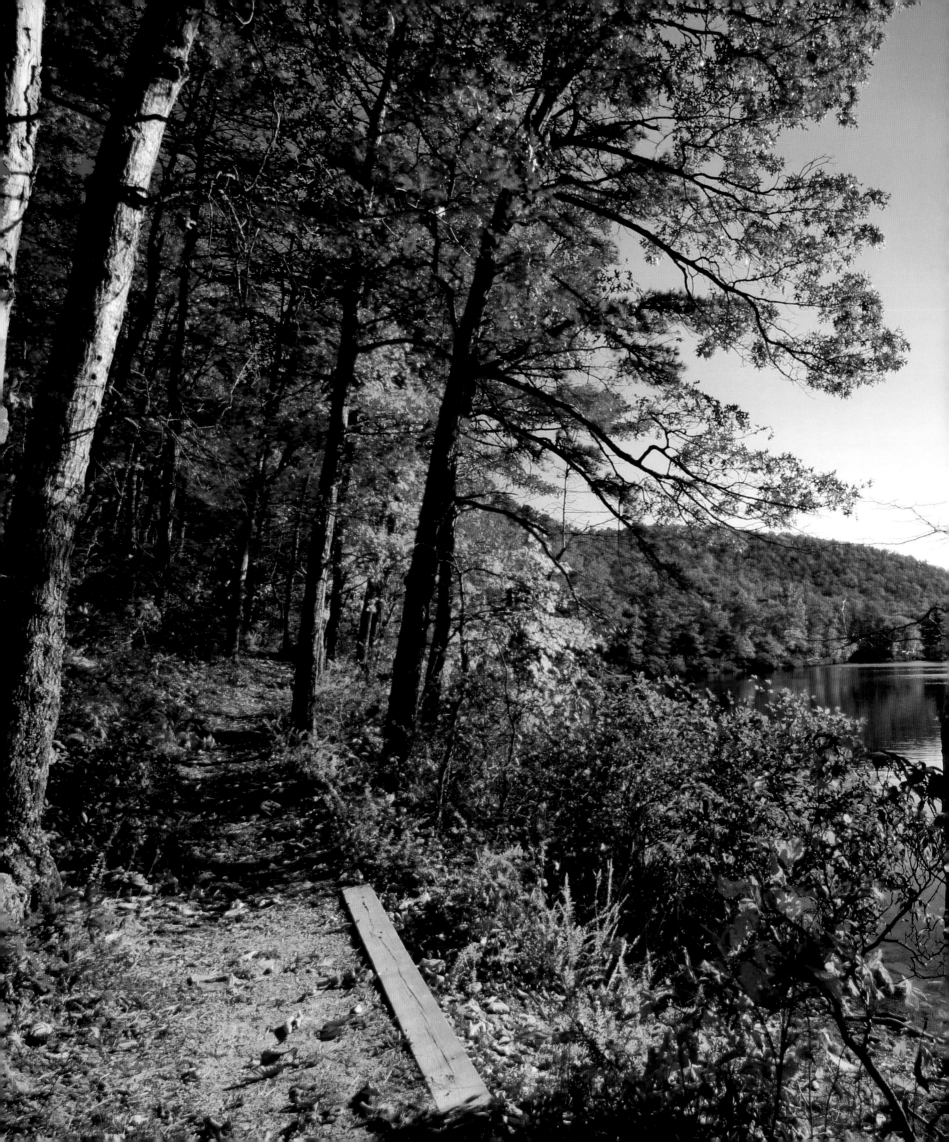

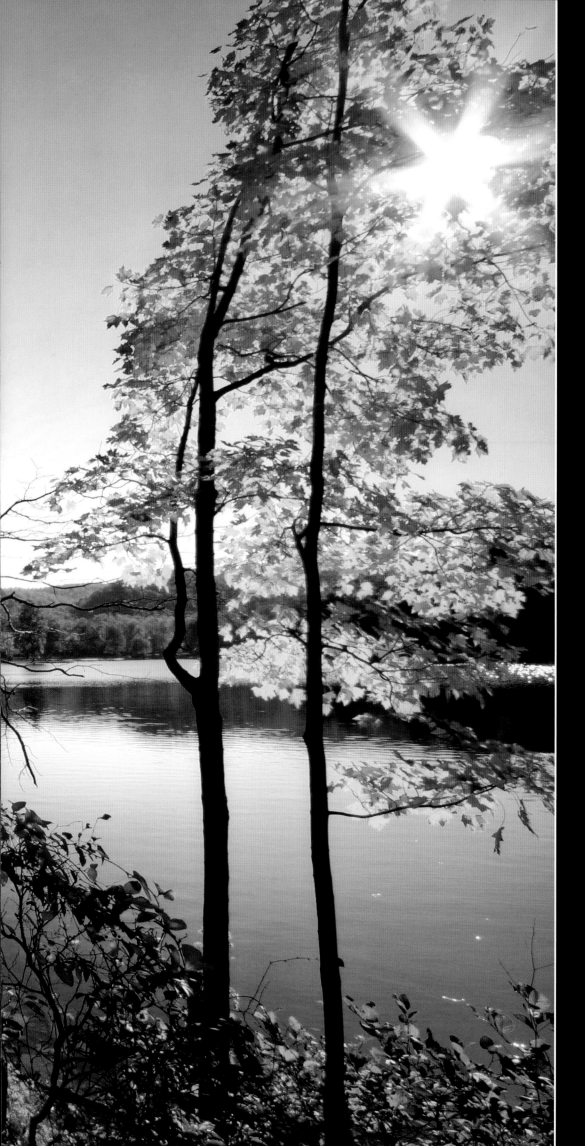

Above: A sunflower blooms in E. B. Jeffress Park, mileposts 271.9 to 274.2 in North Carolina. The 1,008-acre day-use area is home to the Cascades waterfall as well as historic buildings, including the Cool Springs Baptist Church, the Jesse Brown Cabin, and a springhouse.

Left: Sherando Lake in Virginia reflects the colors of October.

1

Above: Mount Airy, North Carolina, is the real-life inspiration for Andy Griffith's Mayberry. North on the Blue Ridge Parkway, near Meadows of Dan, the Mayberry Trading Post, built in 1892, was originally a post office and general store for the community.

Right: The lights of the lodge at Peaks of Otter (milepost 86) reflect in Abbott Lake.

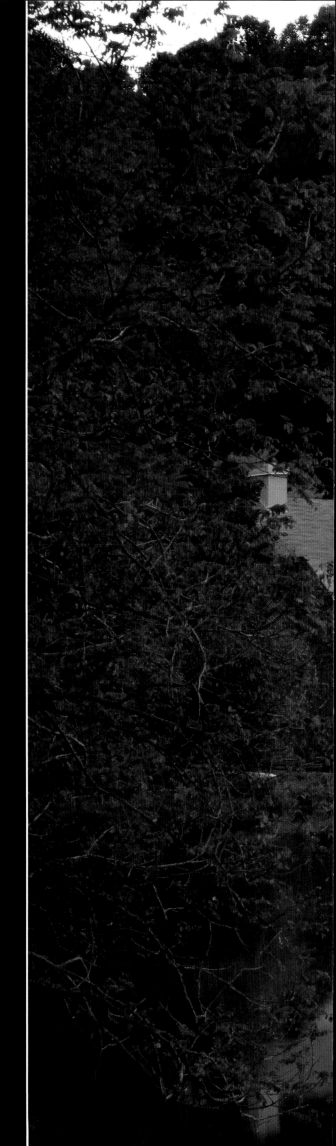

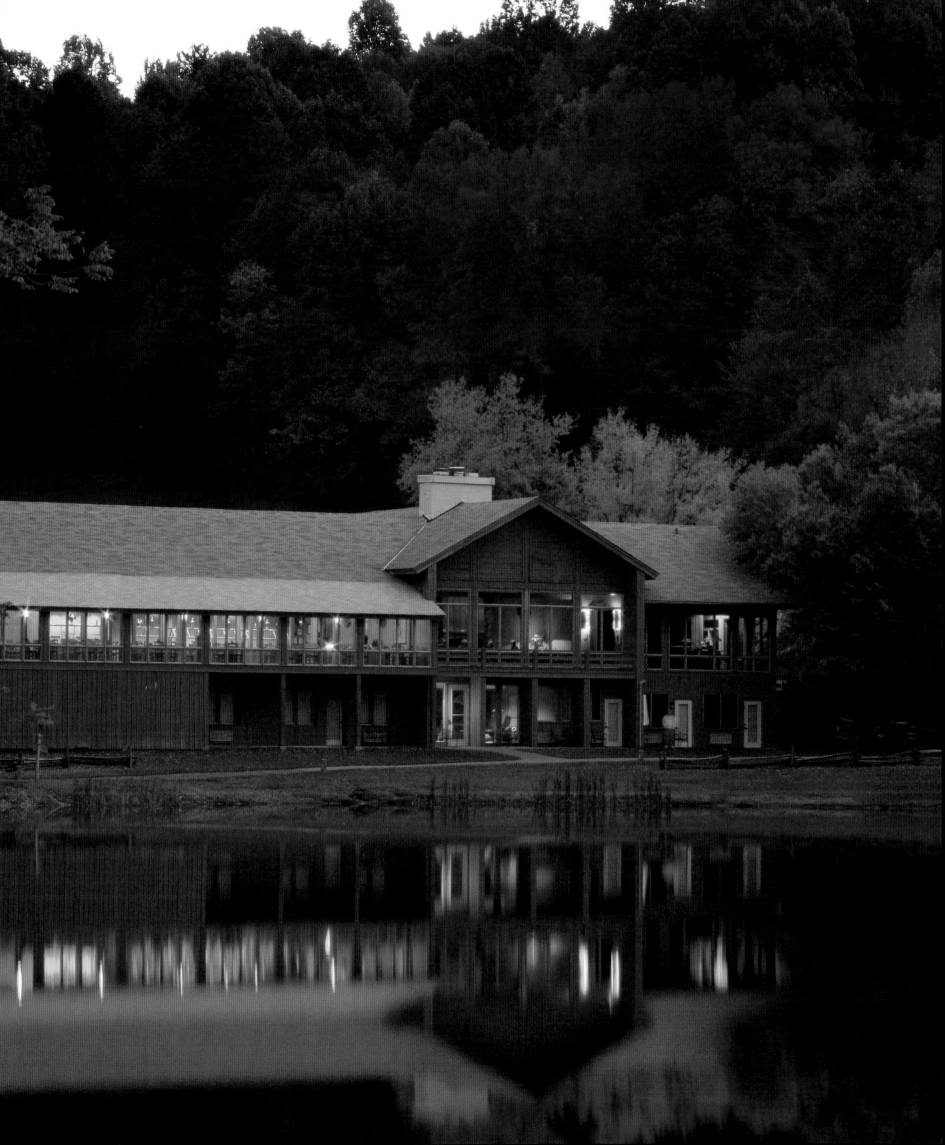

Facing page: Sunset glows on bare trees high on Mount Mitchell in North Carolina.

Below: The parkway disappears around rocky slopes in this view south from Craggy Gardens.

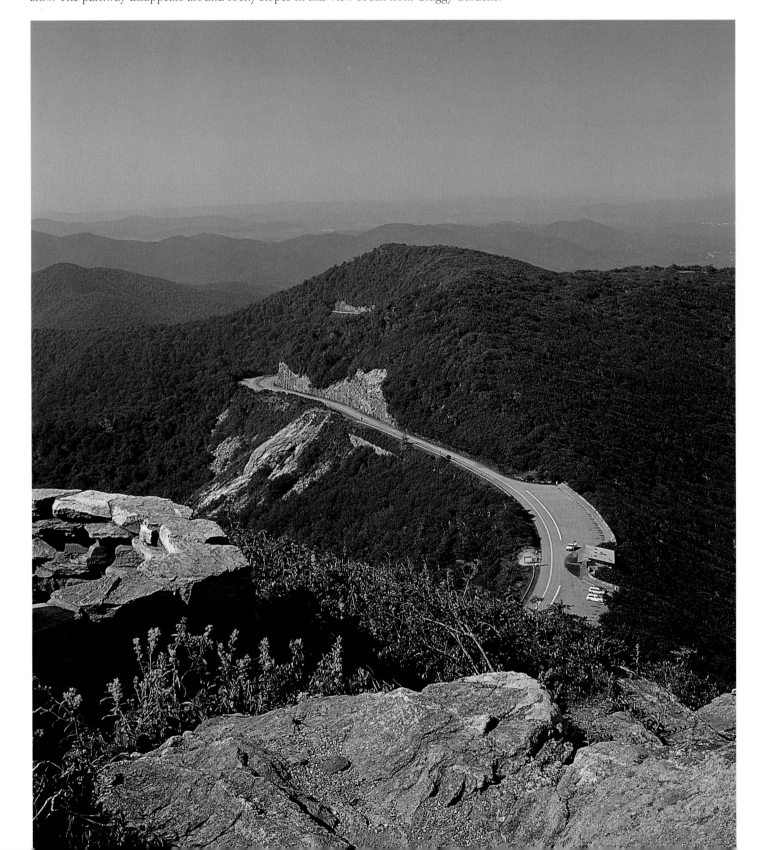

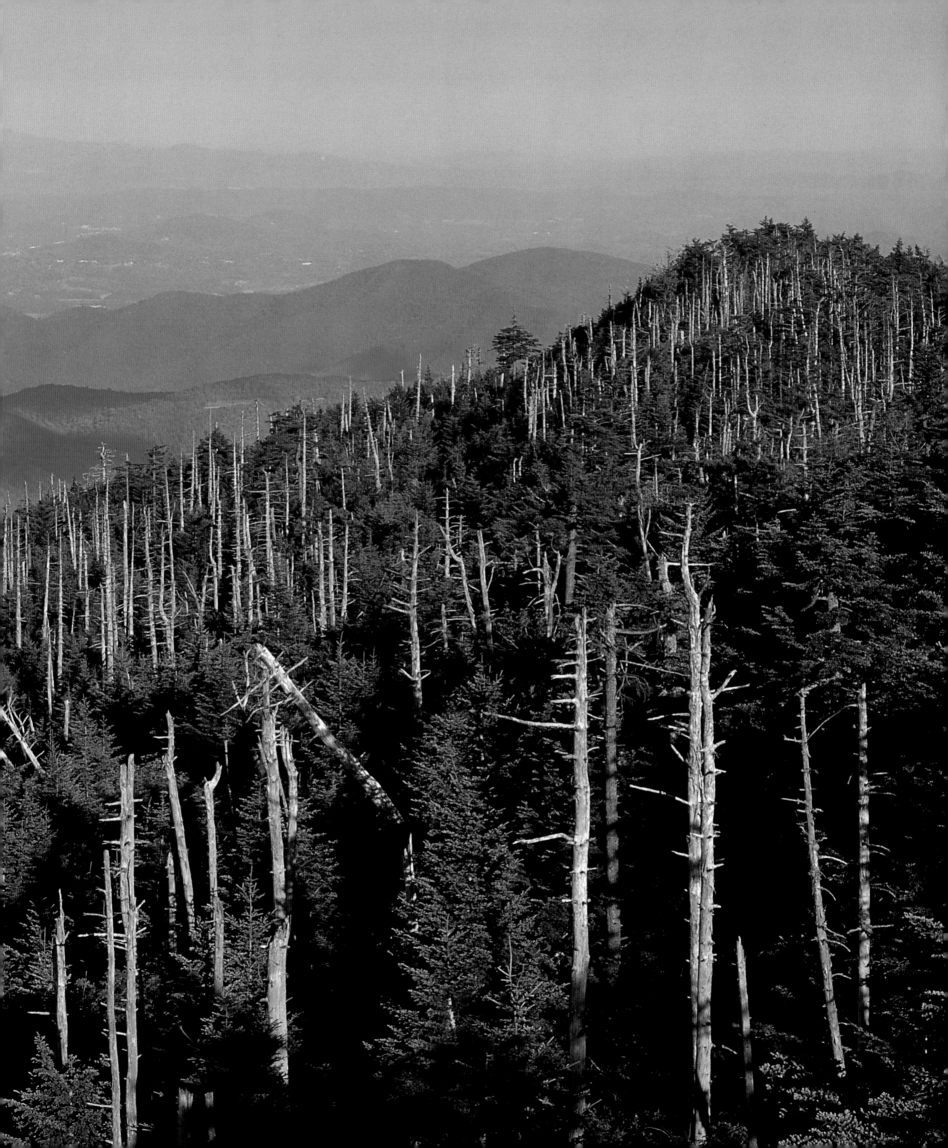

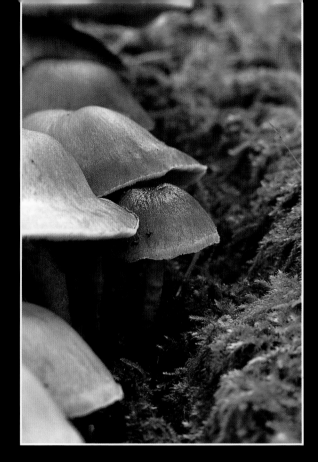

Right: The region's mountains are a perfect habitat for mushrooms. More than 2,000 species of mushrooms have been identified in neighboring Great Smoky Mountains National Park.

Facing page: Trees along the Tanawha Trail near Blowing Rock, North Carolina, appear ghostlike in the mist.

Below: The Brinegar Cabin and one of its outbuildings emerge from the fog in North Carolina's Doughton Park.

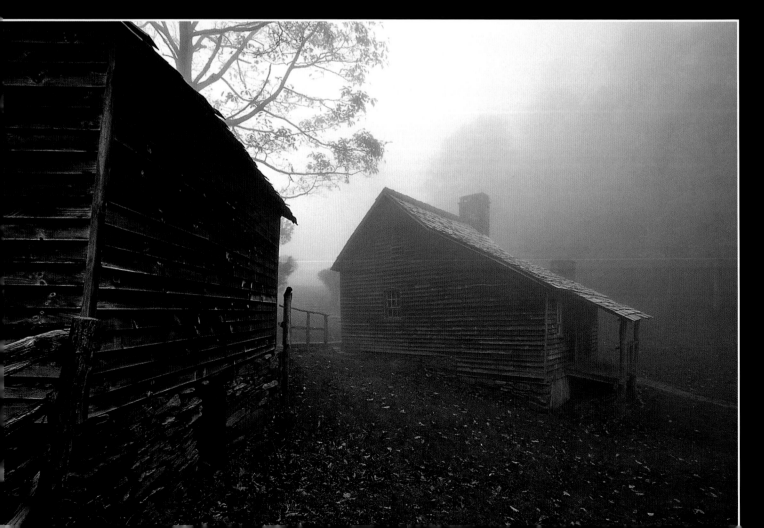

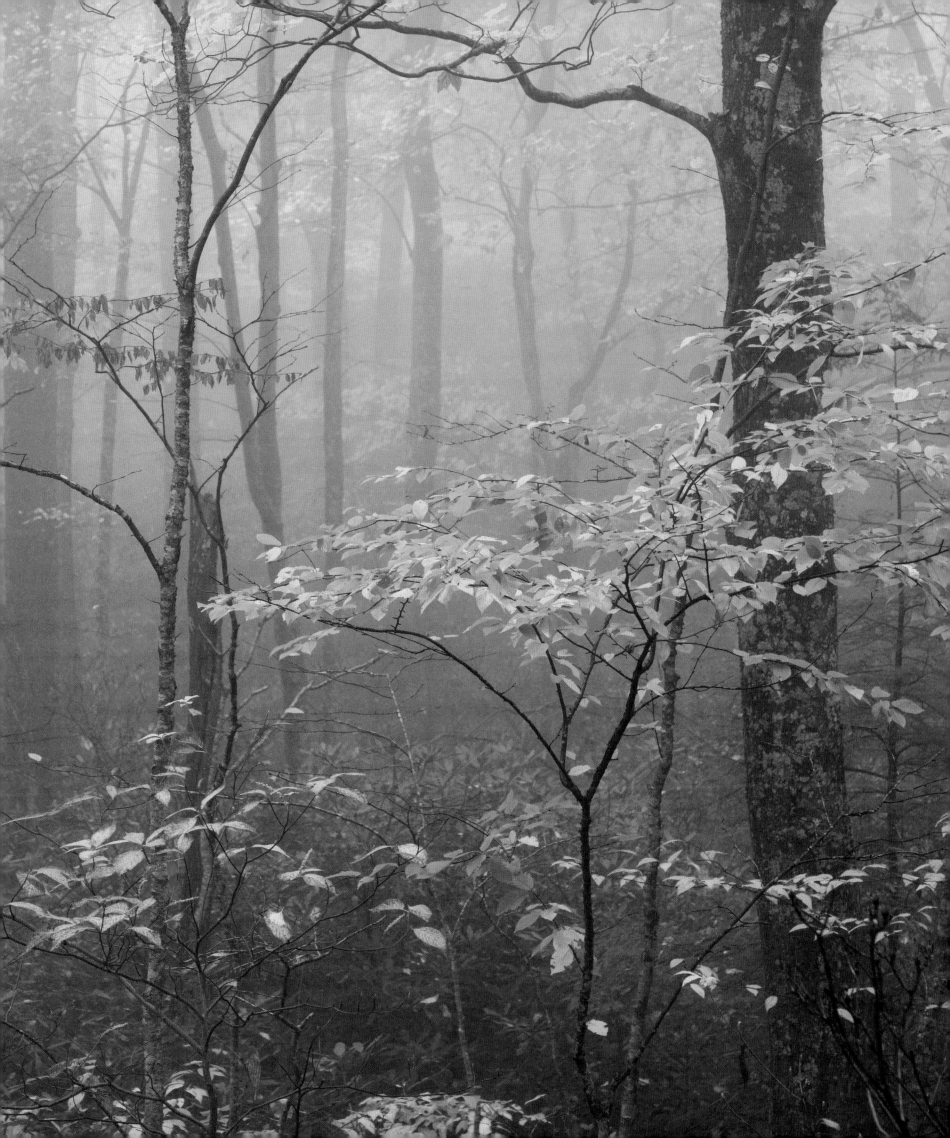

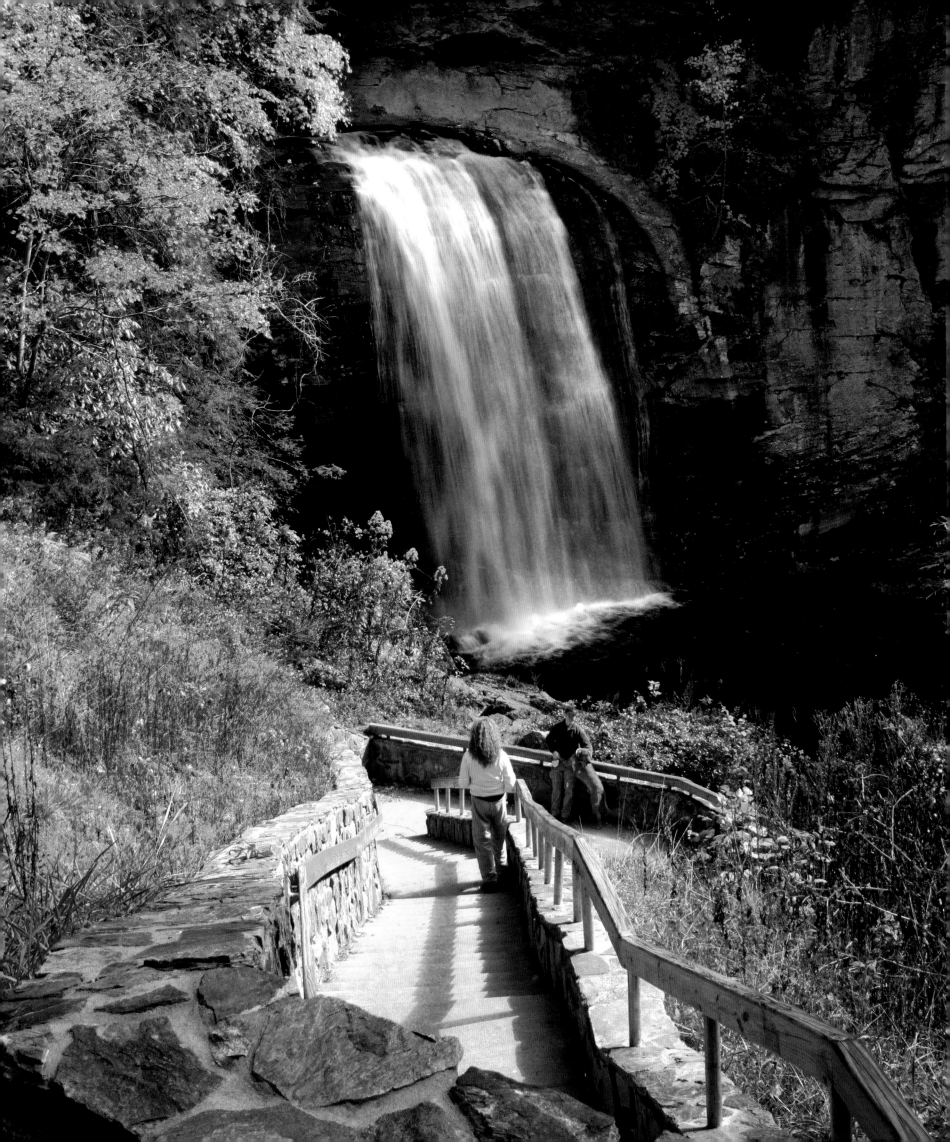

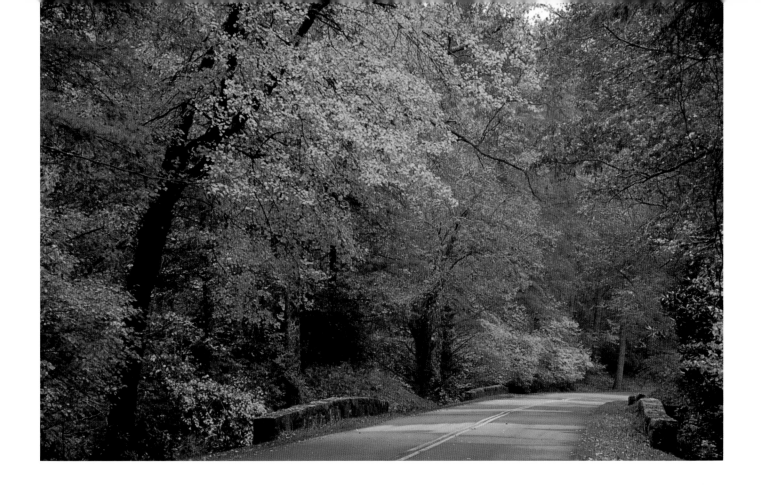

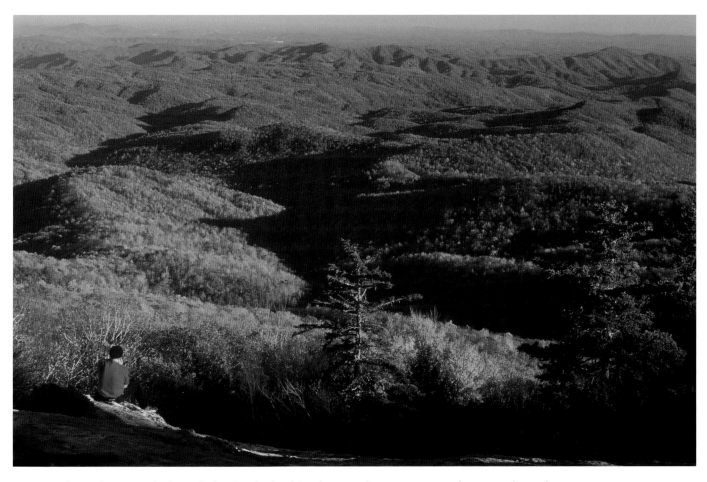

Above, top: The parkway winds through the Cumberland Knob area, where construction began on the parkway in 1935. Cumberland Knob was the first recreation area to open on the parkway.

Above, bottom: Sunset casts shadows at Beacon Heights, around milepost 305 in North Carolina.

Facing page: Looking Glass Falls is one of the reasons Transylvania County, North Carolina, has been nicknamed "Land of Waterfalls."

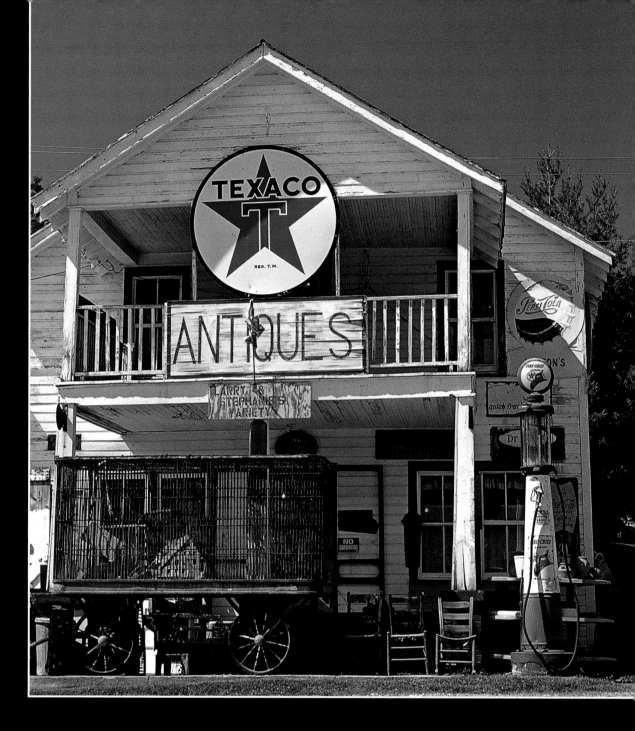

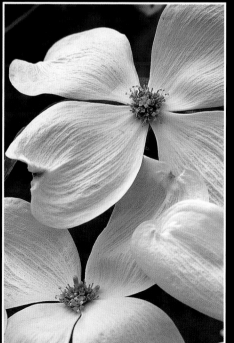

Above: A Meadows of Dan antique store welcomes visitors with its cheerful crowding of nostalgia.

Left: The dogwood is the state flower at both ends of the parkway—Virginia and North Carolina. Its pink and white blossoms start to appear in mid-April and bloom until May at higher elevations.

Facing page: Clouds float past the overlook atop Apple Orchard Mountain in Virginia, north of Peaks of Otter.

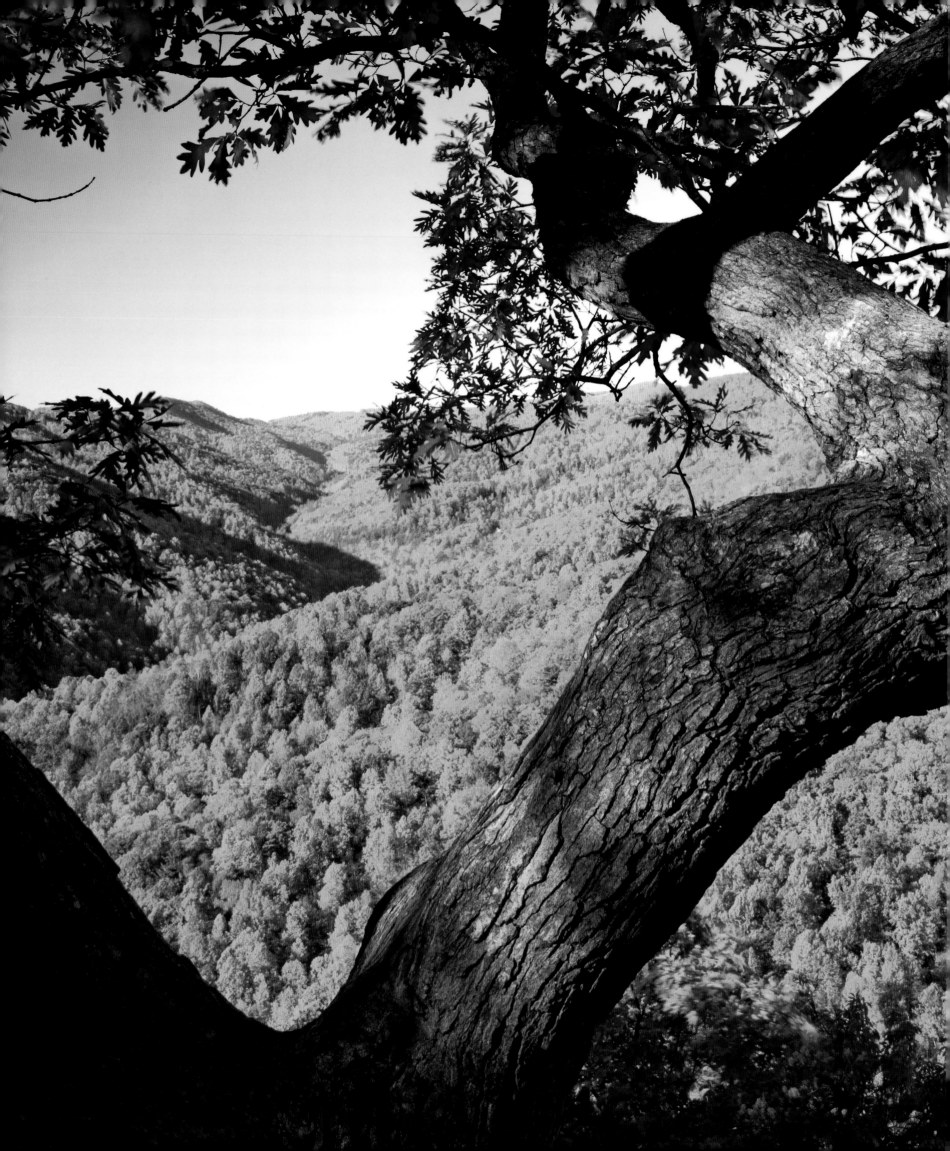

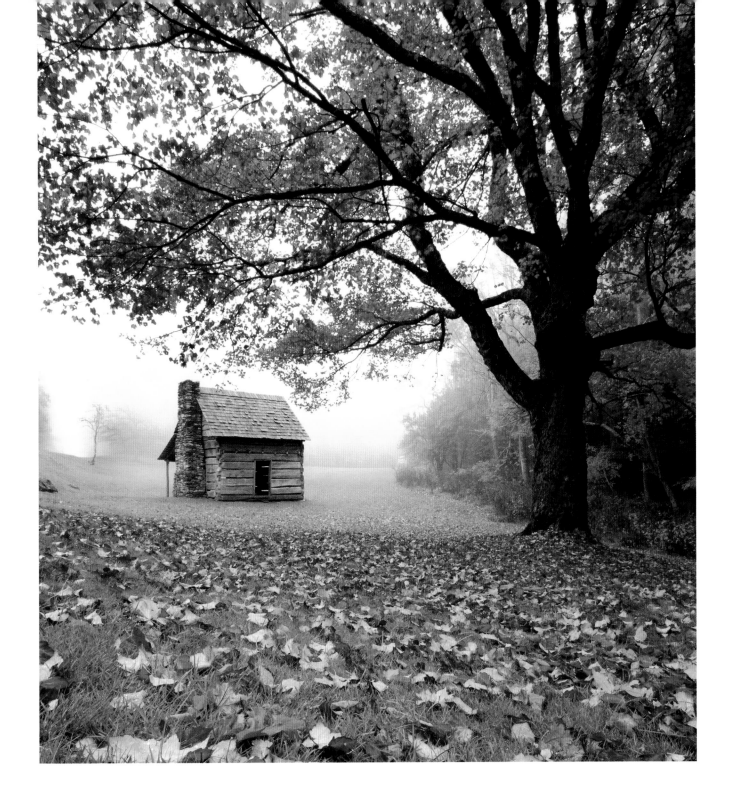

Above: The cabin at E. B. Jeffress Park, at milepost 271.9, is surrounded by a carpet of fallen leaves.

Right: Mushrooms glow among the dead leaves that are their food. The fungi we see are part of a system of filaments running through decomposing organic matter on the forest floor; as they break down, mushrooms take in their nutrients.

Facing page: Sunrise at Twenty-Minute Cliff in Virginia.

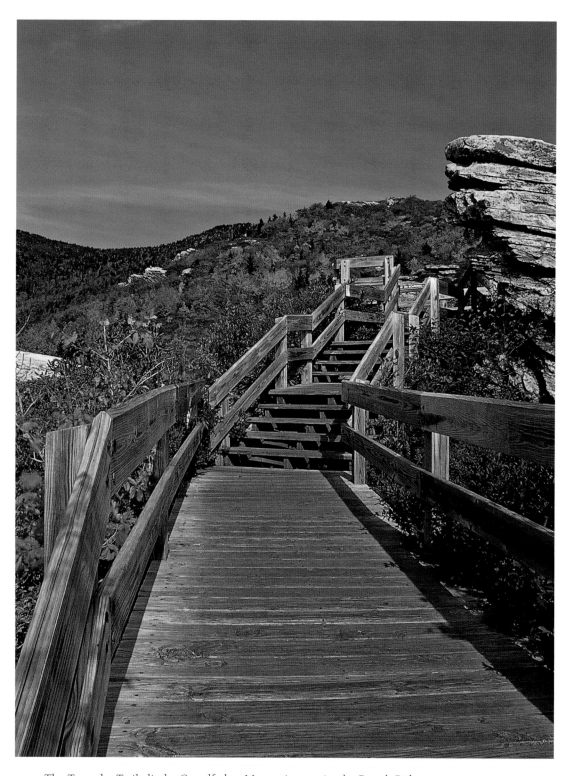

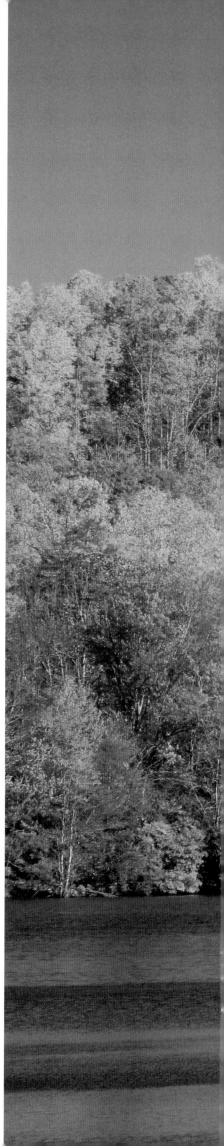

Above: The Tanawha Trail climbs Grandfather Mountain, passing by Rough Ridge.

Right: Forty-seven-acre, trout-stocked Price Lake is part of Price Park, 4,264 acres near Moses H. Cone's Flat Top Manor. The park's hiking trails include a 2.3-mile walk around the lake.

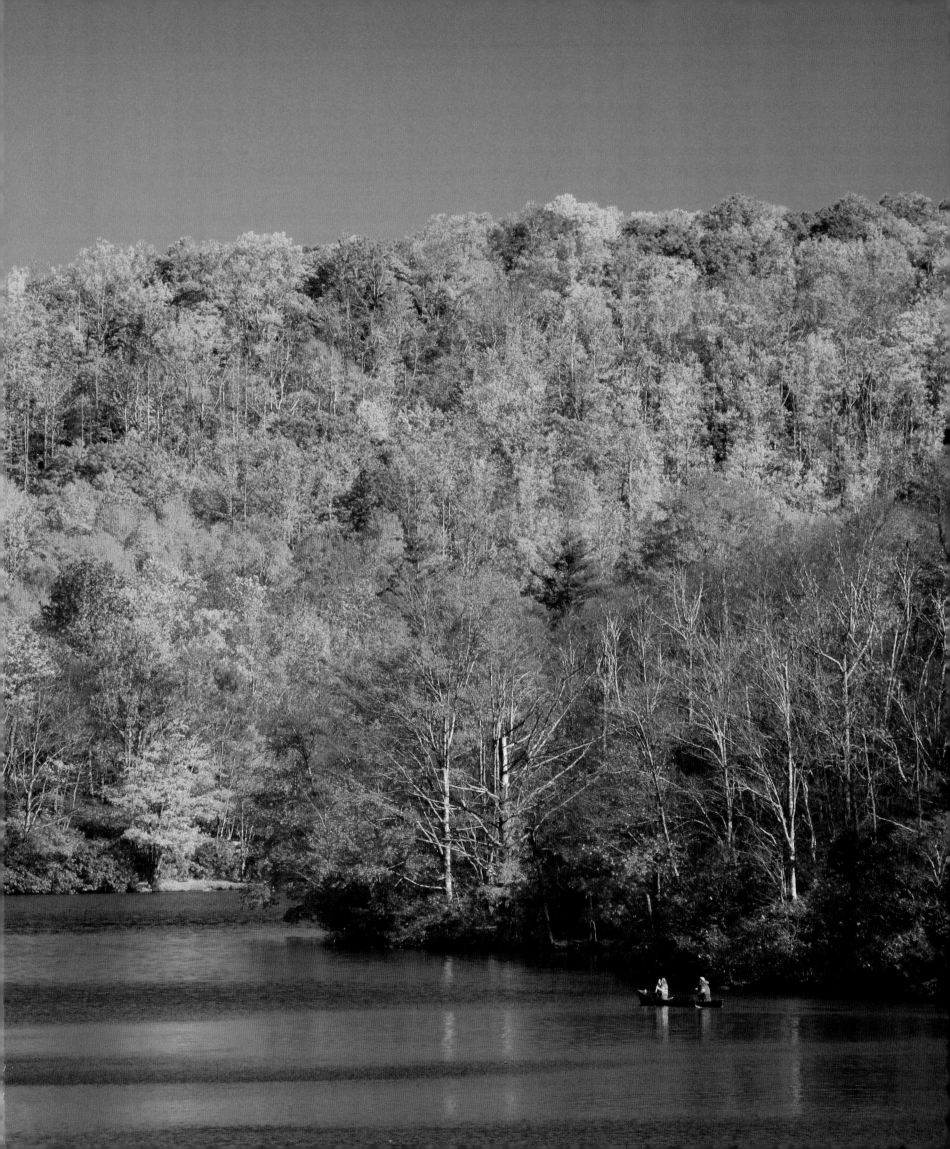

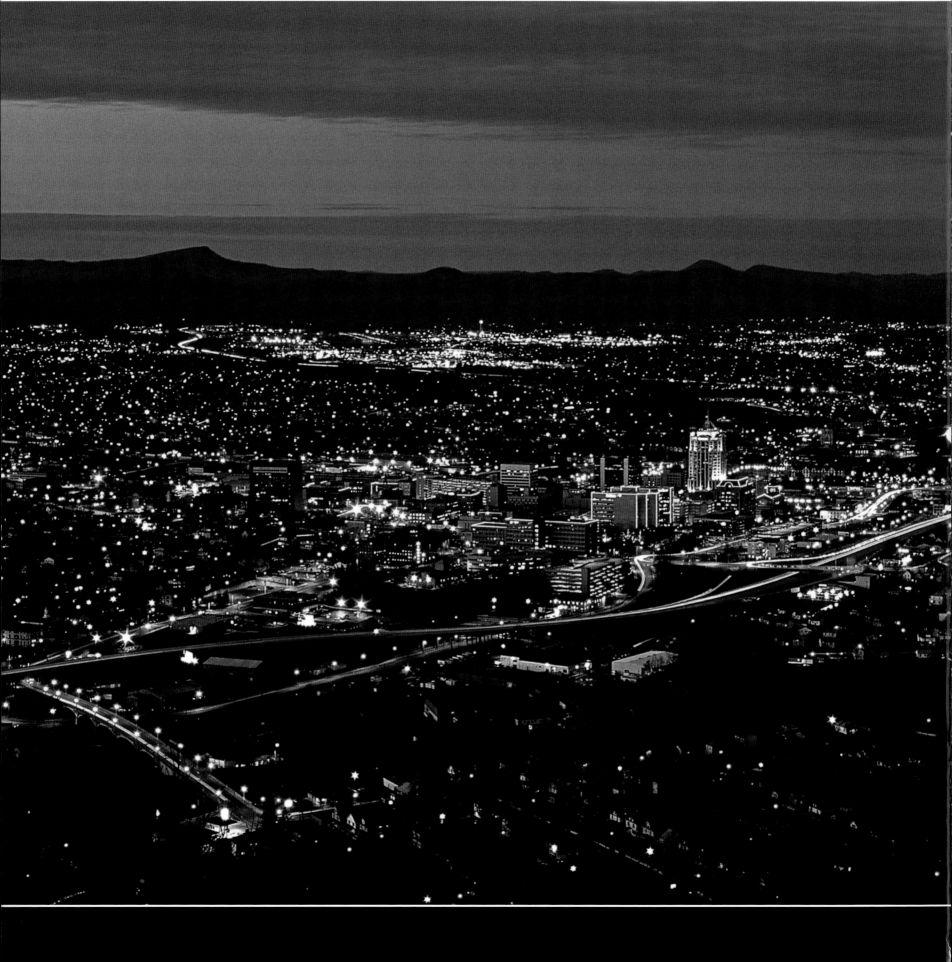

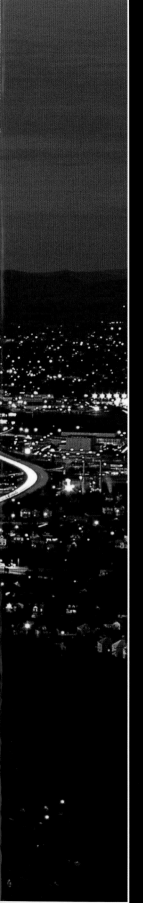

Left: Seen from Mill Mountain, Roanoke, Virginia—one of two cities along the parkway—sparkles at night.

Below, left: The Carolina rose blooms from May through July in dry pastures and open wooded areas.

Below, right: A swallowtail butterfly lands on Joe Pye weed at Cumberland Knob.

Following page: A pastel sky reflects in the historic James River.

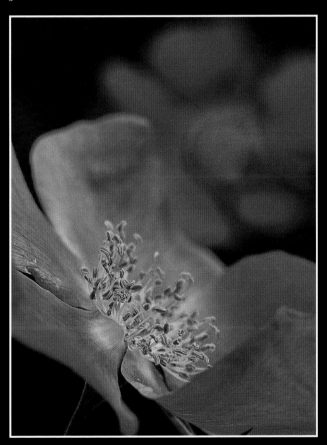

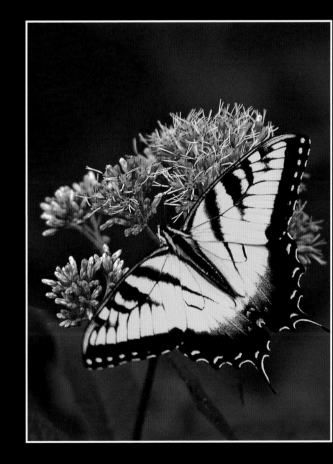

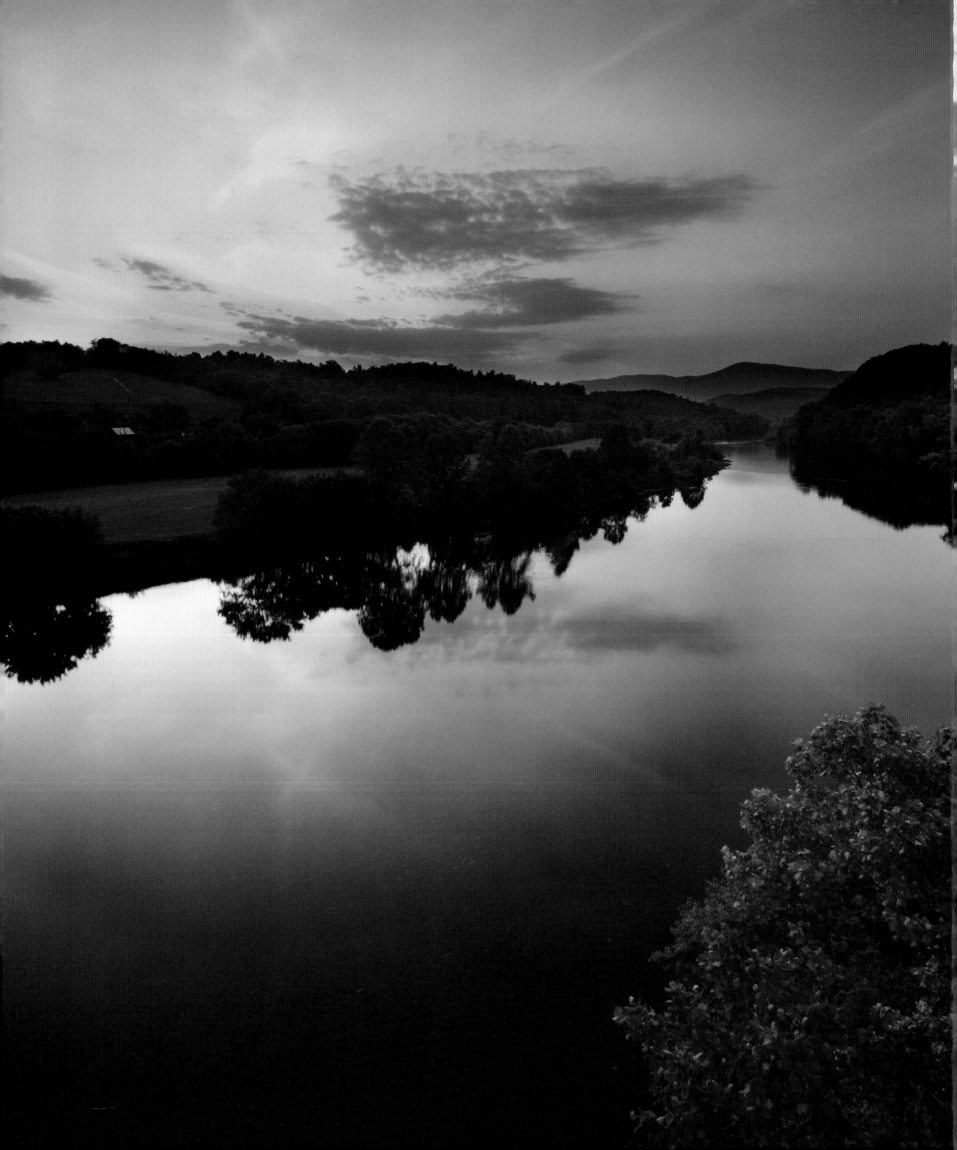